Folk Embroidery
of the
USSR

Nina T. Klimova

Scientific Research Industrial Arts Institute, Moscow

VNR VAN NOSTRAND REINHOLD COMPANY
NEW YORK CINCINNATI TORONTO LONDON MELBOURNE

Printed in the United States of America
Designed by Loudan Enterprises

Published by Van Nostrand Reinhold Company
A division of Litton Educational Publishing, Inc.
135 West 50th Street, New York, NY 10020

Van Nostrand Reinhold Limited
1410 Birchmount Road
Scarborough, Ontario M1P 2E7, Canada

Van Nostrand Reinhold Australia Pty. Ltd.
17 Queen Street
Mitcham, Victoria 3132, Australia

Van Nostrand Reinhold Company Limited
Molly Millars Lane
Wokingham, Berkshire, England

16 15 14 13 12 11 10 9 8 7 6 5 4 3 2 1

Library of Congress Cataloging in Publication Data

Klimova, Nina T
 Folk embroidery of the USSR.

 Includes index.
 1. Embroidery—Russia. 2. Design, Decorative—
Russia. 3. Folk art—Russia. I. Title.
TT769.R9K58 746.44'0947 80-15453
ISBN 0-442-24464-9

Acknowledgments

I am grateful for the kind permission of many orga-
nizations including the Folk Art Museum, the Ex-
hibition Fund, the Storehouse, the Library of the
Scientific Research Industrial Arts Institute, the
Museum of the Moscow Textile Institute and the
Ryazanian and Tambov Museums of Regional
Studies for their materials.

I am greatly indebted to the Assistant Director
P.I. Utkin; the workers of the Laboratory of Em-
broidery and Lace headed by A.I. Fedechkina;
the Curator of Funds of the Folk Art Museum, L.I.
Evdokimova; the art critics, L.P. Sinelnikova and
E.G. Jakovleva; the embroidery artists, E.S. Basa-
nova and O.G. Fedosova; the Chief of the Library,
R.N. Jakovleva; and the Chief of the Exhibition
Fund, R.A. Melechova. These people have helped
me with the preparation of the manuscript and the
selection of illustrations. I am also very grateful to
the artist M.N. Chaet, who made all the drawings
of stitches and graphic sketches for embroideries.

I would like to thank the photographers V.
Obuchova, J. Maximov, A. Kurenkov, M. Roman-
juk and V. Volodin for the preparation of illustra-
tions for the book.

I should like to extend my sincere thanks to the
artists L.S. Filonova, T.I. Ignatjeva, T.A. Dunaeva,
R.A. Kashpar, L.G. Begushina, N.V. Simakina,
T.M. Dmitrieva-Shulpina, N. Kotkova, D.A. Smir-
nova, V. Grunkova, Z. Zaitseva, I. Fedorova, N.
Kiseleva, the workers of the Torzhok Professional
Technical School and the daughter of the artist
K.A. Protsenko for their generous permission to
reproduce their creative works.

Warm thanks are due to J.M. Bir for the transla-
tion of chapter 2 and G.P. Masokina for the trans-
lation of the rest of the book.

Contents

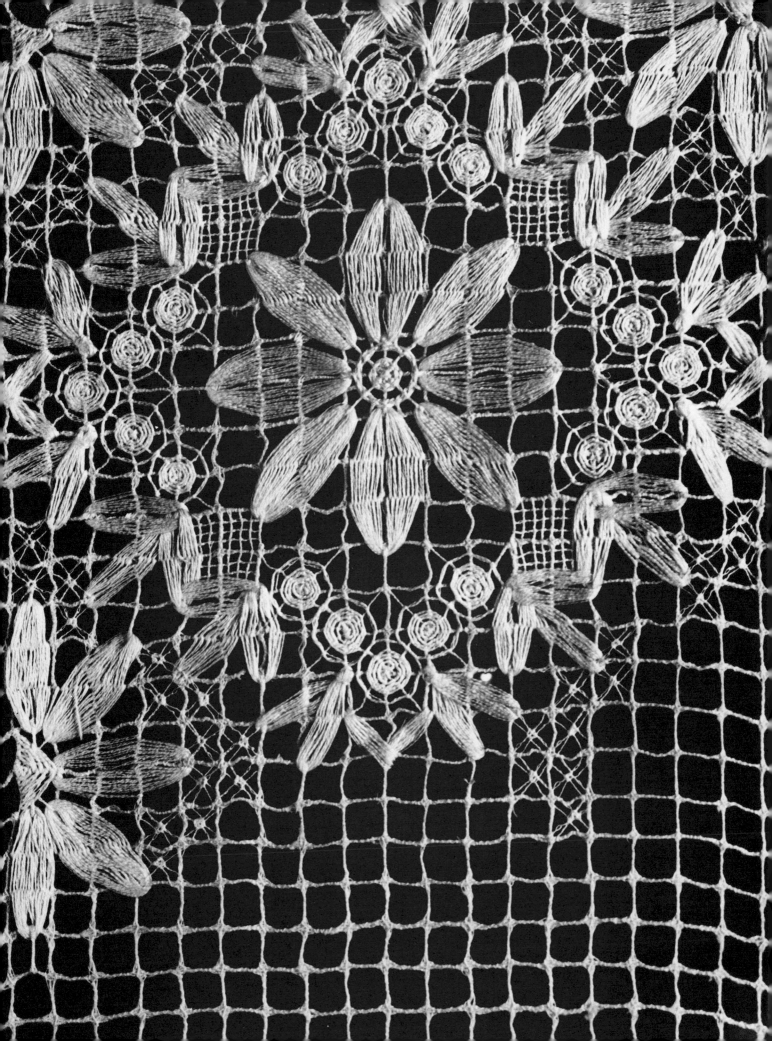

Introduction

Embroidery is a world of unbounded beauty and poetry. From time immemorial each nation has had its own methods of decorating finished fabrics with the help of a needle and thread, its own magic patterns that change a simple article into a work of art.

Embroidery has always been one of the main forms of folk ornamental art. It is closely connected with the people's way of life, their everyday activities and the celebration of their numerous holidays. Embroidery was used for decorating ordinary, holiday and ritual clothing as well as household linen and those articles that form an integral part of rituals of numerous religious ceremonies. In the course of centuries each of the more than sixty nationalities inhabiting the USSR has worked out its own characteristic features of embroidery art and has evolved stable national artistic traditions. It is worth noting, however, that each national art is also characterized by certain features which are inherent in the art of the other related peoples. Thus, similar features in the folk arts of neighboring peoples results in the formation of uniform stylistic groups.

Folk Embroidery of the USSR is concerned with the art of the national folk embroidery of the Russian, Ukrainian, and Belorussian nations as well as of the peoples who inhabit the Volga, Central Asia, Caucasus and the Far North regions. The book summarizes the major characteristics of the folk embroidery of each stylistic group or subgroup represented, discusses the problems of everyday embroidery application, defines the range of motifs and images that were most frequently used in the 18th–20th centuries, and describes masterworks of modern embroidery.

Today the art of folk embroidery of each people is being actively developed. In each republic there are embroidery firms at which highly-skilled embroiderers work. They create a large variety of goods designed for different purposes, including inexpensive modern articles for mass consumption and expensive articles decorated with beautiful folk embroidery and designed for gifts. The skillful embroiderers also create highly artistic works revealing all the beauty of folk embroidery. Such highly artistic works of the present-day embroiderers permanently adorn the expositions of native and foreign exhibitions, gladdening the visitors with the beauty of their ornaments and the perfection of the techniques of the pattern.

The embroidery produced by these firms, which are part of the industrial crafts network in the USSR, is an organic continuation of the folk embroidery of the past. Despite the fact that these modern embroideries are made in factories, they still carry all the traditional characteristics of folk art. The factories themselves are located in the traditional embroidery centers and this leads to the preservation of the technical aspects of the embroidery, the character of the design and the colors used. Examples of these embroideries are shown throughout this book.

Chapter 1

Russian Folk Embroidery

Russian women have always been famous for embroidering cloth with patterns of fantastic beauty. By adorning their garments and everyday linen, they skillfully transformed ordinary fabrics into genuine works of ornamental art. Following ancient tradition, Russian women were taught this complex but fascinating skill from early childhood.

Historical Background

The first known references to Russian embroidery are found in the 10th century. The annals of that period tell us that Princess Olga sent Prince Mal rich gifts, among them embroidered garments. Remnants of embroidered cloth from the 9th and 10th centuries are often found in the numerous archaeological excavation sites scattered throughout the USSR. Usually, these remnants are small fragments of silk cloth, pieces of holiday costumes, decorated with golden and silver patterns. Rings, triangles, lozenges, simple floral motifs and birds are found within the designs.

The costumes of Russian princes and their retainers of that period were rich and multicolored. Judging by sketches on frescoes and miniatures, golden embroidery, coupled with pearls and precious stones, adorned men's and women's long, tunic-shaped garments, cloaks, head-dresses and other parts of the costumes (Figure 1-1).

In the 10th–12th centuries, Russian ornamental embroidery played an important role in the decorative design associated with Christian ceremonies. Cathedrals and cloisters, which in those times were the centers of public life, were abundantly decorated with frescoes and carvings, as well as church-plates of gold, silver and other metals. All this rich decoration was combined with expensive foreign cloth and elaborate embroidery. Gold and pearls iridescently illuminated the curtains closing the "Holy Gates," the shrouds adorning the altar and the church walls, and the vestments of the priests and deacons. Gilded silver threads, colored silk, flax and pearls were used for embroidery. Russian embroiderers of the 10th–12th centuries had a subtle perception of the expressive potential of glittering threads, and they skillfully used the decorative qualities of the stitches popular in those times.

In the following centuries, using ornamental embroidery to decorate clothing became more prevalent, especially in the decoration of the holiday garments of the Russian aristocracy. Men's and women's long, close- or loose-fitting garments, made from straight pieces of cloth, afforded great opportunities for embroidering. Hems, necklines, sleeves and belts were deco-

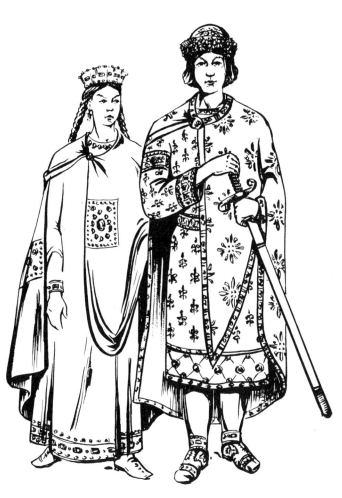

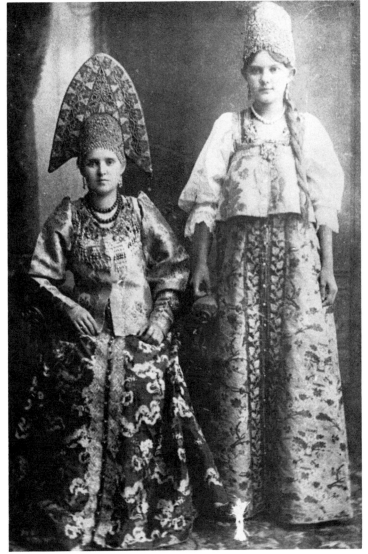

1-1. The ceremonial attire worn by the nobility in ancient Russia in the 11th-13th centuries. From frescoes. (From Strekalov: Russian Historic Clothes, St. Petersburg, 1895.)

1-2. Nineteenth century Gorodetsk merchant women in beautiful costumes made of brocade and colorful silk. Their headdresses include spade-shaped kokoshniks and girl's fillets.

rated. The decorations, however, now grew in size, the ornaments became richer. Anthony Jenkinson, who visited Russia in the 16th century, notes that even at home, persons of high rank wore shirts of fine cloth, embroidered in red silk, gold and sometimes even pearls. The more formal garments were splendidly decorated with metallic threads, pearls and precious stones. Clothing designed to be worn by *boyars*, members of the Russian aristocracy, for the reception of ambassadors and foreign dignitaries were especially luxurious. Nicolas Virkog and Conrad Busov, who came to Russia at the end of the 16th and at the beginning of the 17th centuries, and who were present at the reception of foreign ambassadors, recorded that *boyars* of high rank could be looked upon with nothing less than delight. They wore glittering garments of brocade, embroidered in silk and decorated with pearls and precious stones.

Decorative needlework was highly appreciated in ancient Russia. The embroidery was its owner's pride, and it was cautiously kept in the family and passed on from generation to generation. Unfortunately, at present little is known about the decoration of the common people's clothing, but there is no doubt about the fact that their garments were decorated with embroidery. According to ancient Russian custom, each woman, no matter who she was, had to be proficient in the fine art of sewing and embroidery—these skills were highly respected. In each family, poor or well-to-do, the women made all the clothing and other household necessities. In the houses of prosperous people, the main workshop of the household was the *svetlitza* (the women's part of the house). The *svetlitza* was headed by the mistress of the house and her daughters, who themselves were highly skilled in the art of embroidery, and who spent all their free time with embroidery hoops in their hands. The main purpose of the *svetlitza* was to make various church vestments and gifts, as well as clothing and bedding for the family. Embroidery in silk and gold was of the utmost importance. The most talented needlewomen embroidered shirts and chemises, collars, caps, sleeves, belts and other parts of garments. The merits of the Russian embroideries of the 15th–17th centuries were due to the consummate skill of these needlewomen, to the beauty of the ornament, and to the diversity of geometric and floral motifs.

Embroidery in Russia did not lose its significance in subsequent centuries. In the 18th–20th centuries, Russian embroidery was very popular in the families of traders, officials and handicraftsmen, as well as in country-seats, peasant homes and private workshops of larger towns.

As before, beautiful patterns, embroidered in gold and silver and in white and colored threads, were widely used in decorating clothing and household linen. But the style and character of the Russian ornamental embroidery were suddenly changed. This was due to sharp changes in the tenor of life of various social strata of Russian society that took place at the beginning of the 18th century. Carrying out economic and cultural reforms, the Russian Tsar, Peter I, forcibly abolished the old-fashioned garments of the period. This marked the beginning of the Europeanization of the Russian costume. According to the decree of the Tsar, everyone except clergymen and peasants was obliged to dress in the "foreign" fashion. Courtiers and nobles of the capital became the first groups to be dressed in German and later in French styles. These new costumes had to be decorated in new ways. Russian embroidery, which for many centuries had developed in one definite direction, began to develop at the beginning of the 18th century in two separate directions: secular and folk. Though the two trends were closely connected, each of them was characterized by its own peculiar features.

Uses of Embroidery

Born many centuries ago, Russian folk embroidery was of the utmost importance in the lives of the Russian people of the 18th and 19th centuries. During these two centuries, folk embroiderers created matchless masterpieces in which the best achievements of the past and current ages were organically combined. Russian peasant women of the 18th and 19th centuries were unusually skilled in embroidery techniques. At the age of five, they began to learn the art of embroidering together with other skills: spinning, weaving and, in some districts, lace-making.

1–3. The folk holiday costume from the end of the 18th and the first half of the 19th centuries. Made on silk and velvet with muslin sleeves embroidered with gold threads. The headdress has a podnis of mother-of-pearl. (From a series of postcards, The Ancient Women's Costume of Different Peoples of Russia, *1915. Photograph by N. T. Klimova.)*

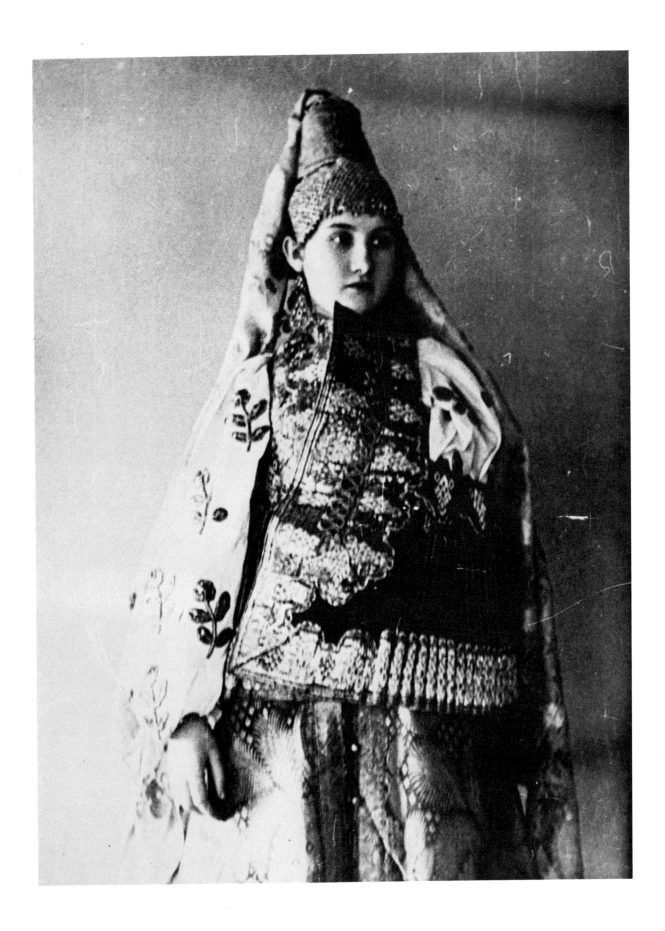

In accordance with ancient customs, wives and daughters in peasant families were obliged to provide the family with all necessary clothing and household linens. To begin with, each girl had to make her own trousseau. This was considered to be the basis of the prosperity of the newly-created family. The trousseau was also a criterion for evaluating the merits of the bride. Her diligence, abilities and taste were judged by the number of articles prepared, the perfection of patterns woven and embroidered, and the harmony of colors she used. The number of articles often reached several hundred and consisted mainly of everyday and holiday garments that the bride prepared for herself for all possible occasions. Included were shirts, aprons, *sarafans*, lined jackets and headdresses. In preparing the trousseau, the Russian woman displayed her talent, rich imagination and mastery in full measure.

The bride had to prepare about fifty shirts for her family life. First of all, she made the wedding shirts, of which there were many. When a man met his new fiance for the first time after the agreement between families had been made, she wore a bright multicolored shirt. In the days preceding the marriage ceremony, when the girl "grieved" over the loss of the free life she had had in her parents' house, she wore a simply embroidered white shirt. During the marriage ceremony, the bride wore a white dress with wide, light or bright, multicolored embroidery. The shirt that the bride wore immediately after the wedding ceremony was the most beautiful of all; it blazed with red and was decorated with complex multitiered patterns.

The trousseau of the Russian peasant girl included not only her clothing but special towels (ritual cloths) as well. These towels were the bride's main gift to her new relatives and all honored guests. Several towels were needed for the wedding day—in well-to-do families the number of towels reached two hundred at times. As with her clothes, the peasant girl began to prepare wedding towels from her childhood and completed this work only after the marriage had been agreed upon and the exact number of future relatives was known. The bride was expected to show much ingenuity and a rich imagination in preparing gifts with patterns that would please her future relatives and show them what a fine needlewoman was going to become a member of their family. The gifts were distributed by a matchmaker, godmother or a bridesmaid.

It should be noted that bright colorful towels, curtains and tablecloths were not only used for decorating a peasant wedding; they were widely used for many solemn as well as joyous village festivals throughout the year. On great feasts such as Easter, Trinity Sunday and the locality's Patron Saint's day, a peasant house was transformed; it was filled with bright multicolored articles. Beds were covered with festive bedsheets. On particularly solemn occasions, two or even three curtains, each with a different embroidered pattern, were hung on the sides of the bed. A mountain of pillows in bright pillowcases with wide open-work bands were piled on the bed. The table was covered with an embroidered or woven tablecloth. A particularly festive atmosphere in the peasant house was created by embroidered towels. Dressers and icons were covered with these snowy white towels that were decorated with red calico, colored embroideries and sewn-on bright ribbons.

The Tver province had an ancient custom of adorning village streets with towels on holidays. In other regions, birch branches were twined with brightly decorated towels as a part of summer festivals. The whiteness of the towels contrasted with the greenery of nature and the brilliant colors of the holiday costumes.

Folk Costumes

In the costume of Russian women, the canvas or red calico shirt was the brightest and smartest article of clothing. It was decorated with woven or embroidered patterns and with various ribbons, tapes and cords. The number of patterns depended upon the woman's age and the purpose of the costume. A young girl wore a shirt whose pattern was simple and not very bright (Figure 1-5). The design ran around the hem, the sleeves and the low neck. Women's shirts, on the other hand, were brighter and more colorful. But the most beautiful of all was the shirt of the recently-married young woman. This shirt could only be worn until the birth of the woman's first child. After the birth of each child, the number of patterns and colors gradually decreased and the fabrics used for the headdress got simpler. By the time the woman reached old age, the beautiful color and glittering decorations almost disappeared from her costume; the color and patterns got simpler and the color white prevailed.

Besides the above-mentioned garments, there were special ones for special occasions; for example, funeral clothing was embroidered only in white. On Church feast days and holidays, Russian peasants also wore special clothes, of which the woman's shirt worn on the first day of meadow grass mowing was the most beautiful (Figure 1-6). It was often made of red calico, linen, or bright small-patterned cotton and embroidered with multicolored patterns. In the northern and central provinces, holiday costumes of brocade, patterned with silk, were widely worn by prosperous peasants. Also decorated with embroidery were beautiful headdresses, kerchiefs and shawls which glittered with golden grasses. Women's headdresses were high and came in various shapes. The lower part of the headdress and the so-called *podnis* were brightly patterned with mother-of-pearl (Figure 1-2). Girls often wore headdresses in the form of an open-worked crown with a mother-of-pearl *podnis* lowered down to the forehead and the long strands of the *rjaska* covering the ears (Figure 1-3).

1–4. The ceremonial blessing of the betrothed couple after the marriage agreement has been made. The girl's father holds an icon supported by an embroidered towel. (The Peasant Wedding by Akimov, 1820. Photograph by N. T. Klimova.)

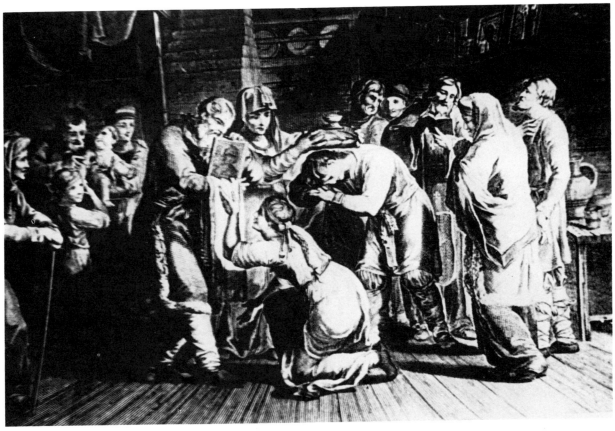

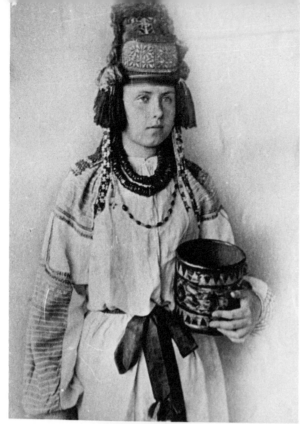

1-5. A girl's costume worn in Tula province in the 19th century. (From Shabelskaya: Peasant Art in Russia, The Studio, London, Paris, MCM XII, Plate 38. Photograph by N. T. Klimova.)

1-6. A skirt worn on the first day of the mowing of meadow grass. Made of linen with colorful weaving in combination with embroidery in the counted satin stitch technique. Archangelsk province, end of the 19th century. (Museum of Folk Art. Collection of photographs of the Scientific Research Industrial Arts Institute.)

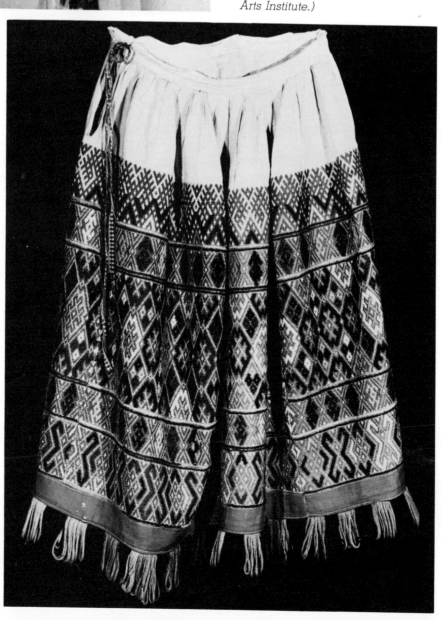

Traditional Designs

In embroidering clothing and household linen, a Russian peasant woman did not change the traditional placement of patterns. This was determined by the article's form and the garment's style. Thus, she always decorated both ends of towels and tablecloths with one or several rows of bright plain or patterned stripes. Bed curtains were most often wholly decorated but sometimes they were only embroidered along the lower hem. The ornamentation of these articles was usually characterized by symmetrical composition or by the regular repetition of clear-cut forms making an ornamental row. The red color prevailed as a symbol of warmth, sun, joy and life. It was often combined with green, sky-blue, golden and orange tones, which created a rich and cheerful range of colors (C-1). White embroideries were also very popular.

However, despite strict rules for pattern location and composition and for the colors of decoration of everyday and holiday linen, one cannot find two similar patterns among thousands of samples. Each of them differs from the others in the variety of motif combinations, in the ornament proportions, in the quantity of accompanying plain and patterned stripes, as well as in their color and rhythm. Here the imagination of folk needleworkers was limitless. They had to know all the secrets of the art of decorating clothing and everyday linen and had to have outstanding taste in order to create a decoration, each time in keeping with the character of their local traditional art but at the same time expressing their individuality. The art of the folk needleworkers was most often revealed in the harmony of the ornament, in the significance of the pattern or picture depicted and in the selection of motifs through which they tried to express their wishes and dreams.

In folk embroidery of the 18th and 19th centuries, one can find a great variety of pictures, motifs and images. Geometric and floral motifs, pictures of birds, animals and people are found in each province and in each district. Geometric motifs were of special importance in counted stitch embroidery. In the geometrical ornament, strictly linear outlines of shapes were preferred, with the different shapes of the lozenge playing the leading role. In the period of growing agriculture and the cults connected with it, the lozenge, in Russian folk embroidery, symbolized many different images. A clean lozenge and a lozenge with a sprout symbolized the sun, fire, fertility and the

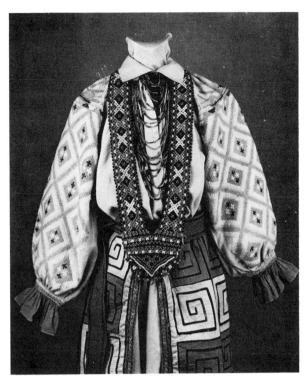

1–7. A woman's costume of the Orel province from the end of the 19th century. (Museum of Ethnography of the Peoples of the USSR. From Proceedings of the Scientific Research Industrial Arts Institute, *No. 4, 1967, p. 368, fig. 107. Collection of photographs of the Scientific Research Industrial Arts Institute.)*

renewal of life. A lozenge with two diagonals was an ideogram of a field and a new building (a row of logs of a wooden house frame), a chain of lozenges signified the tree of life, etc.

Ancient Slavs thought that these signs-symbols on their clothing and other everyday articles could protect them against the hostile forces of nature and promote a happy course of life. Later, people forgot the magical sense attached to these signs-symbols but continued to consider them as depicting benevolent motifs. They became the basis of ornamental composition development.

The geometric ornament was formed gradually over the course of several centuries. By the 19th century, the lozenge was often combined with other geometric forms: rectangles, triangles, stars, etc. Motifs of the geometric ornament varied and changed according to local traditions. Each province was characterized by its own range of motifs and by its own system of composition.

Besides geometric motifs, pictures of flowers and bushes, birds and animals, architecture and people were used widely (Figure 1-10). These figurative motifs were executed both with counted stitches and free stitches (not deter-

mined by the cloth texture). It was a specific, incomparable, and poetic world of images in which fantasy was connected with real observations of surrounding nature. Here, peahens with fluffy, fan-shaped tails, majestic swans, small ducks or cocky roosters stood in beauty among slender trees, transparent bushes and symmetrical grasses. They were often grouped around a single tree or lined up in single file. On other embroideries, one could see deer with branch-like horns galloping among plants, prancing horses with outstretched necks, or grandly marching and exotic snow leopards. As with geometric motifs, this poetical world of images was filled with the multidimensional symbolism connected to the activities and to the whole tenor of the villagers' lives. In ancient times, many images of folk embroidery were connected with the religious beliefs of the Slavs, whose main beliefs were in the cults of the Sun and the Earth. The main deity was the goddess of fertility. This goddess was always depicted as a majestic woman surrounded by birds, flowers and horsemen. Russian folk embroideries of the 18th and 19th centuries often used this strictly static composition with the figure of a woman in the center.

In the 19th century, however, besides the highly popular pictures of goddesses, there appeared a group of other embroideries in which ancient symbolism was changed and traditional images were gradually given another content reflecting the interests of the people of those times. Their hopes for a prosperous life once again formed the basis of their new interests. But in the 19th century the urban life of merchants and handicraftsmen came to be the criterion of well-being—not a rich harvest gathered in the peasant land.

On the one hand, traditional decorative motifs became the basis for depicting people's festivals and ceremonies, reflecting ideas of a prosperous peasant's housekeeping. Embroideries with pictures of birds, flowers, snow leopards, horses and horsemen were often understood by the peasants to be symbols of good and prosperity in family life, agreement and love between a wife and a husband. On the other hand, traditional images interpreted in another way became the basis for depicting genre scenes of urban life. For this reason embroidery depicted well-dressed girls dancing in a ring, horses with horsemen galloping in a line, palaces, parks, a betrothed couple in beautiful holiday costumes, and ladies in fashionable gowns with fans or parasols in their hands (Figure 1-9).

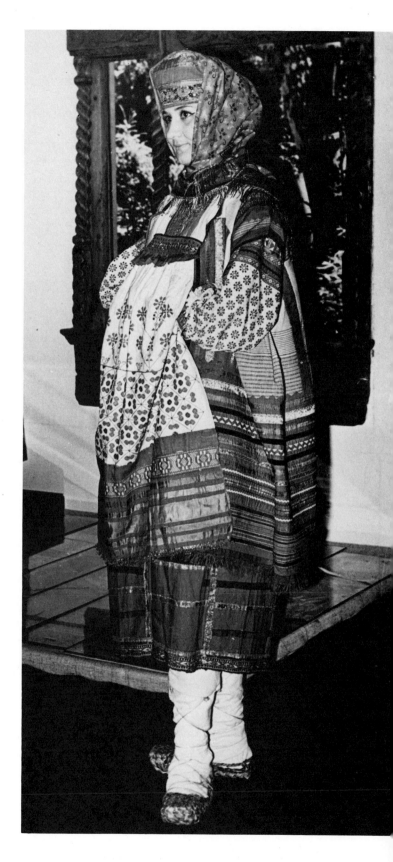

The Russian folk embroidery of the 18th and 19th centuries was characterized by various techniques of executing the embroidery. Russian peasant women cherished the characteristic features of the embroidery of their locality, permanently enriching and developing it. However, despite obvious differences in embroidery techniques and stylistic peculiarities of the ornament of a given province, Russian folk embroidery may be combined in several groups, depending on the technique of executing the pattern. Stitches based on counting the cloth's threads or executed on a picture with a free contour, as well as stitches that were laid on the background surface or were woven into the structure of the linen were equally widespread. Folk embroiderers used familiar techniques to execute a pattern in different ways. Sometimes they used only one stitch; more often they combined two or three stitches together creating a beautiful texture. The embroidery was often combined with patterned weaving, laces, ribbons and stripes of plain and multicolored cloths comprising a complex ornament glittering with different colorful insets.

The high traditions of this Russian folk embroidery still continue to be the basis of the embroiderer's creative work today.

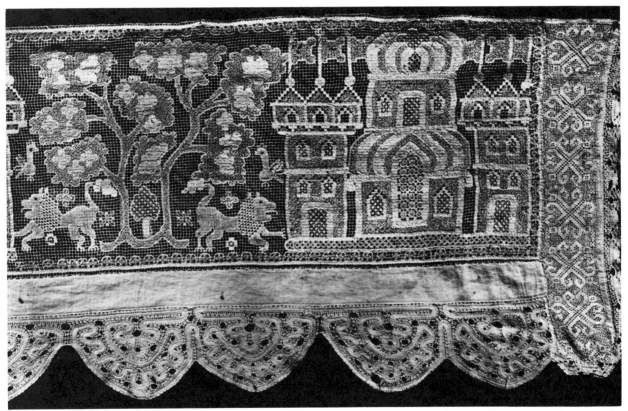

1–9. A bedcurtain with pictures of palaces, trees, birds and animals. Made on linen with white stitch and bobbin lace. Moscow province, the 19th century. (Museum of Folk Art.)

1–8. A woman's costume of the Ryazan province (Michailovsk district). The end of the 19th century, beginning of the 20th century. (From Proceedings of the Scientific Research Industrial Arts Institute, *No. 4, 1967, p. 369, fig. 108. Collection of photographs of the Scientific Research Industrial Arts Institute.)*

This embroidery can be used to adorn many articles. Small, light patterns (Figure 2-3) can decorate women's and children's clothing. Large patterns (Figures 2-4, 2-5) with birds, figures of women and trees would look better on tablecloths, curtains, cushions and other household articles. Such embroidery can be white against a colored background, red on light-colored cloth or multicolored, where the predominating red is combined with light and dark blue, golden, and green shades; the last was the custom of embroiderers of the Tver, Novgorod and Vologda provinces.

Preparation

Before embroidering, a place for the ornament must be chosen on the article. The fixed dimensions of the ornament require that the number of stitches and their length (which range from three to five fibers, depending on the texture of the cloth) be calculated. This is done on graph paper. Next, several stitches are made on a sample piece of cloth to determine the thickness of the thread to be used. The thread can be made up of one or several thin strands, depending on the length of the stitch and the texture of the cloth. Short stitches made with one thin thread look well on fine, filmy fabrics whereas longer and thicker stitches are better suited for fabrics with heavier textures.

Before embroidering large ornaments, which involves counting a great number of fibers, it is advisable to mark the outline of the design on the cloth. The design is first plotted on graph paper and the length of the stitches carefully calculated, after which the design is transferred to the cloth with the help of dressmaker's carbon paper or transfer pencils.

Large designs should be made with six to eight strands of thread, otherwise the embroidery will be flat and colorless, hardly discernible at a distance, and the article, which the embroiderer has taken such pains to adorn, will lose much of its beauty. Whereas, if the ornament, its proportions, the thread and the length of the stitch are well chosen, the embroidery will delight the eye with its rich motifs, the variety of smaller designs filling in each form, the intricate texture and delicate color scheme.

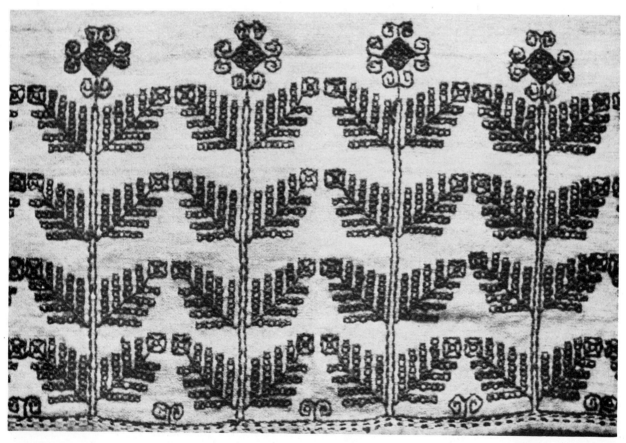

2–2. End of a towel with a floral ornament. Made on canvas with "painting" stitch. Olonetsk province, the 19th century. (Museum of Folk Art. Photograph by N. T. Klimova.)

2–3. Three designs for "painting" embroidery; these can be used to decorate summer clothing and small pieces of household linen.

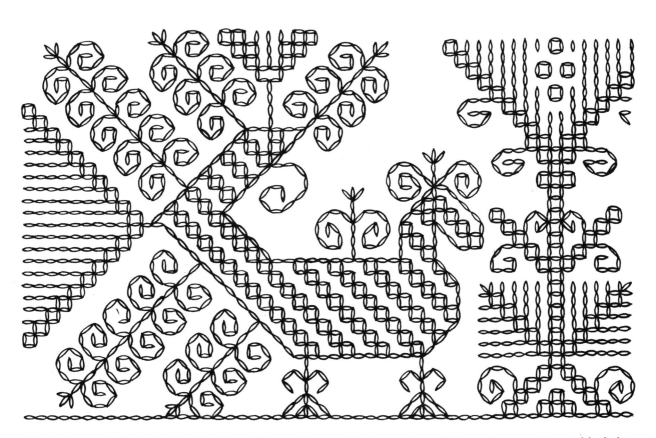

2–4. A design for "painting" embroidery. This can be used for decorative articles such as curtains, tablecloths and sofa cushions.

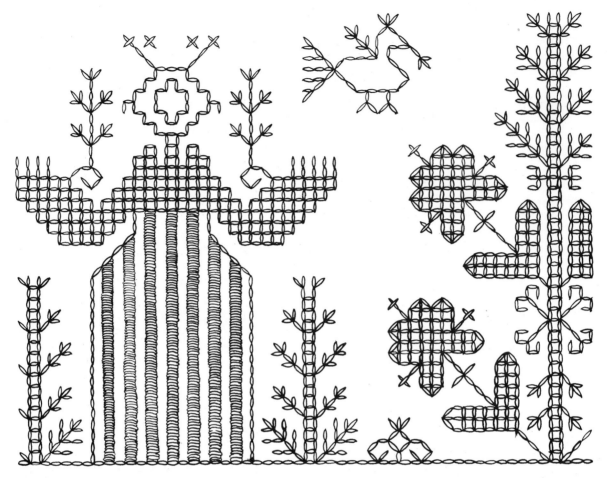

2–5. A design for "painting" embroidery on decorative articles.

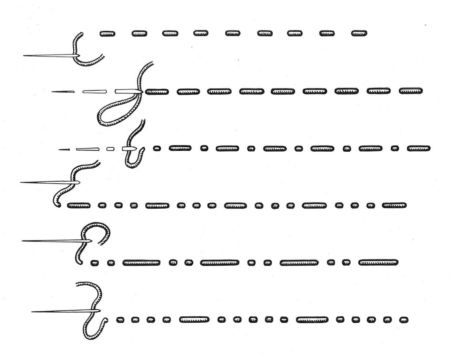

2–6. Running stitch.

Technique

The stitches used in the "painting" technique are outline stitches and are based on an exact count of the cloth fibers. Stitches of equal length form a colored line which can be straight, zigzag, or stepped, and runs horizontally, vertically or diagonally on the cloth. Each ornamental figure thus outlined acquires a strictly geometric form with clear-cut angles.

The technique is based on the simple running stitch which makes a row of sparsely-spaced single stitches and dotted lines. For each stitch, a definite number of fibers are picked up by the needle, after which a certain number, depending on the pattern, are skipped, with the thread always working forward (Figure 2-6). One stitch and the space between stitches may cover three, four, five or more fibers and the length may vary.

In double-sided "painting" embroidery, the running stitch is also used, but the thread doubles back on itself, making stitches of equal length on the right and wrong side of the cloth. To begin with, stitches are made in one direction, and, on the way back, the thread covers the spaces between stitches (Figures 2-7, 2-8). The same space is seldom covered twice. For a straight diagonal or a stepped line, the needle, on its way back, must go into the exact prick made by the previous stitch.

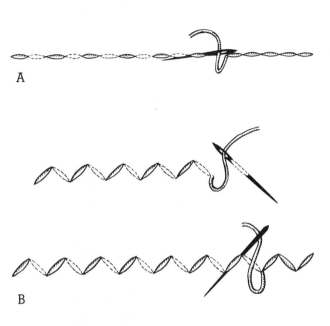

2-7. The double-sided stitch used in "painting": (A) a straight line, (B) a zigzag line, (C) embroidering separate ornamental forms and the marks made in transferring the design to the cloth, (D) a patterned band.

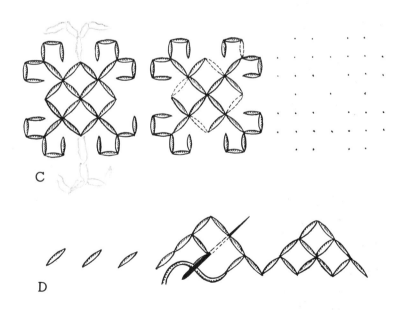

A

B

C

D

Nabor and Counted Satin Stitch

Nabor and counted satin stitch, like "painting," belong to the group of counted overstitches, but the designs worked with these stitches are different from those used in "painting." Ornaments made in the "painting" style are as dainty and transparent as light-colored lace, organically woven into the texture of the cloth; the designs in the former styles are rich, bright and solid, and seem to be laying on the surface of the cloth. This is achieved by placing stitches close to each other to evenly fill in each ornamental form.

These styles of embroidery also differ in the choice of motifs. Ornaments in *nabor* and satin stitch seldom represent plot pictures. Geometric patterns and geometrically treated floral designs predominate (Figure 2-9). In the 18th and 19th centuries, counted satin stitch and *nabor*, as well as "painting," were widely used throughout the Russian countryside. Embroidery in the northern provinces was all in red; in the south, it was mostly multicolored, bright and joyous, with a perfect rhythm of scarlet, blue, green, golden, violet and crimson shades creating a complex color scheme (Figure 2-13). On folk articles, these two stitches were often combined with plain and patterned bands of colored cloth (Figure 2-10).

Figures 2-11 and 2-12 show two examples of these techniques. The designs can be arranged in one patterned band hemming the article or in two or three tiered bands. Intervals between these brightly-colored ornamental bands may be equal or vary, depending on the composition. A wide patterned hem can also be combined with smaller motifs, rhythmically arranged against the background (Figure 2-13). As in "painting," the composition would be incomplete without a band of bright colored cloth, the same color as the design or close to it in shade, fringing the article below the last row of embroidery. Red against a light background predominates in Russian folk embroidery, though variants are possible.

2–8. "Painting" stitch: (A and B) designs filling in large forms, (C and D) the face and back of a floral motif embroidered in the "painting" stitch. Follow the numbers for thread work.

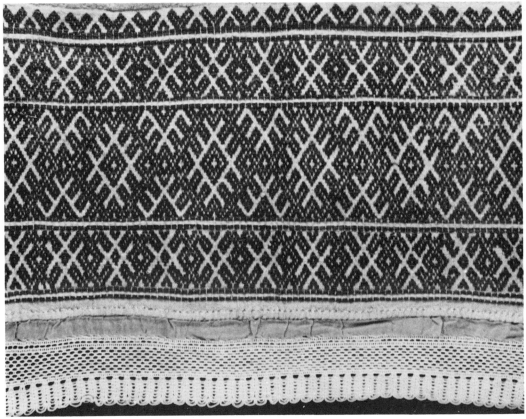

2–9. End of a towel showing a geometric ornament. Made on canvas with nabor. Vologda province, the 19th century. (Photograph by V. M. Obukhova.)

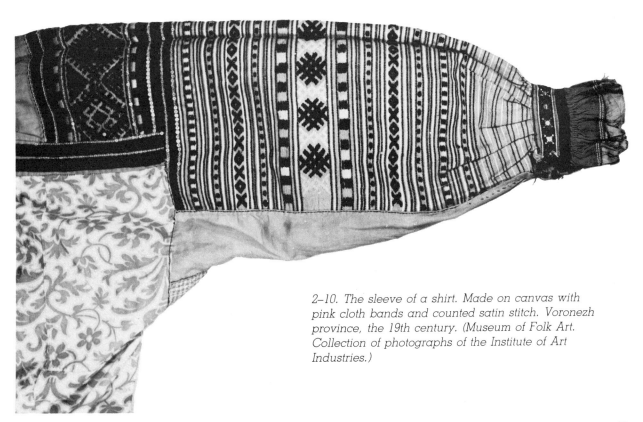

2–10. The sleeve of a shirt. Made on canvas with pink cloth bands and counted satin stitch. Voronezh province, the 19th century. (Museum of Folk Art. Collection of photographs of the Institute of Art Industries.)

Technique

Nabor and counted satin stitch often look alike. In both cases, closely-placed parallel stitches fill in ornamental forms with bright color. However, there is a fundamental difference between these stitches. They are different in threadwork and in the position of the closely-placed stitches in relation to the warp and the weft.

Nabor. Nabor is a weaving stitch; the needle and thread act like a shuttle passing under and over the warp. All the stitches go in the same direction, parallel to the cloth fibers and most often horizontal in relation to the ornamental forms (Figures 2-14 and 2-15). The threadwork is always parallel to the previously made row of stitches, the needle alternately picking up and skipping a definite number of fibers (Figure 2-16).

One stitch is made on the right side of the cloth, the next one on the wrong side, and gradually the whole ornamental composition emerges— squares, lozenges, crosses and other simple geometric forms. When this technique of embroidery is used, the pattern on the wrong side of the cloth is a negative to the one on the right side. The two diagrams in Figure 2-16 show the face and back of a piece of *nabor* embroidery.

The length of the stitches depends on the nature of the ornament, the texture of the cloth and the thickness of the thread; stitches are shorter on a blouse made of a delicate fabric and longer on fabric used for tablecloths or window curtains.

2–11. A design for nabor *embroidery.*

2–12. A design for counted satin stitch embroidery.

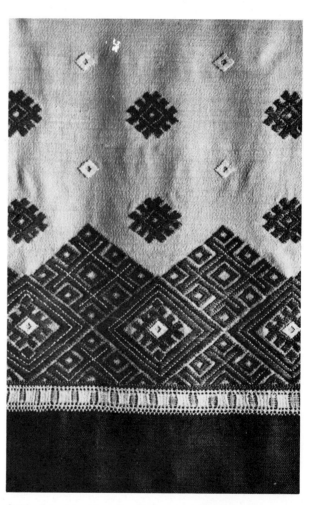

2–13. An example of geometric composition in counted satin stitch embroidery. (Photograph by N. T. Klimova.)

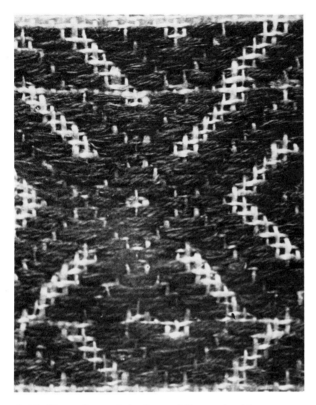

2–14. The nabor *stitch: face of the embroidery.*

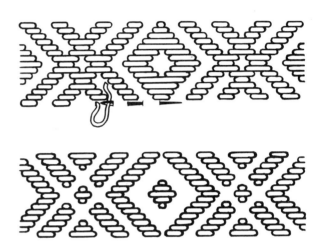

2–16. The nabor *stitch: (top)* face, *(bottom)* back. *The threadwork is shown by the position of the needle.*

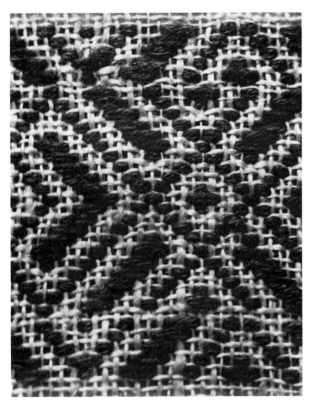

2–15. The back of the embroidery shown in Figure 2–14.

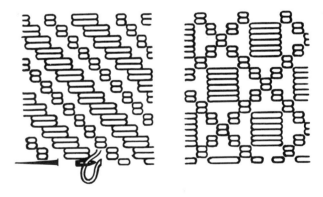

2–17. Two designs that can be made using the nabor *stitch.*

The embroiderer must be very careful to correctly alternate stitches of equal length; otherwise the clear outlines of the motifs will be broken. It is likewise unadvisable to make stitches too long, lest they sag and break the smooth surface of the embroidery.

Counted Satin Stitch. In the technique of satin stitch, the pattern does not emerge as a whole, but, rather, separate motifs appear on the cloth one after another. After a stitch is made, the thread goes back, the needle piercing the cloth beside the preceding stitch. The patterns on the right and wrong sides of the cloth are identical. The closely placed stitches of such embroidery may go in various directions (Figure 2-18, 2-20).

According to these directions, we distinguish the following types of satin stitch:

Simple satin stitch, where straight rows of stitches, parallel either to the warp or to the weft, cover the surface of the design (Figure 2-20A).

Oblique satin stitch, where stitches are parallel to each other, but diagonal in relation to the warp and the weft (Figure 2-20B).

Open fishbone stitch, where diagonal stitches are made in opposite directions at an angle to each other (Figure 2-20C).

Star stitch, in which the thread goes from the rim of the figure to the center and back, thus forming a star-shaped pattern (Figure 2-20C).

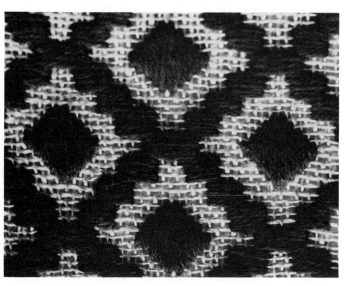

2–18. Counted satin stitch.

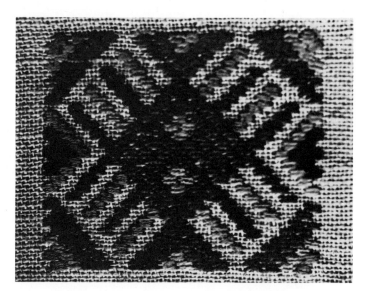

2–19. Another example of counted satin stitch.

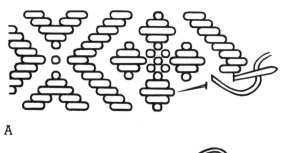

A

B

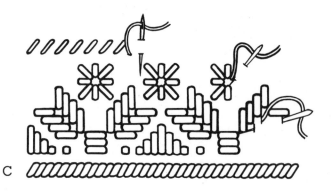

C

2–20. Counted satin stitch: (A) simple satin stitch, (B) oblique satin stitch, (C) combination of the simple and oblique satin stitches, open fishbone ("fir-tree") and "star."

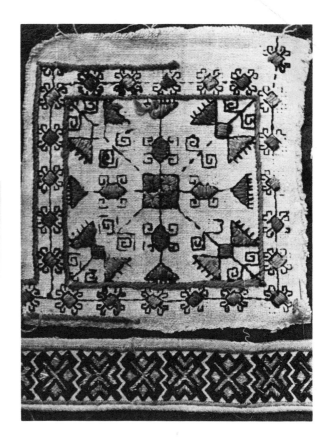

2–22. The end of a head towel. Made on canvas with "painting," and counted satin stitch. Tambov province, first half of the 19th century. (Museum of Folk Art. Photograph by N. T. Klimova.)

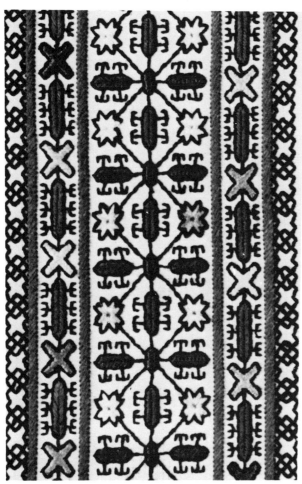

2–21. The end of a head towel. Made on canvas with "painting," and counted satin stitch. Tambov province, first half of the 19th century. (Museum of Folk Art. Photograph by V. M. Obukhova)

2–23. A design for "painting" and counted satin stitch embroidery.

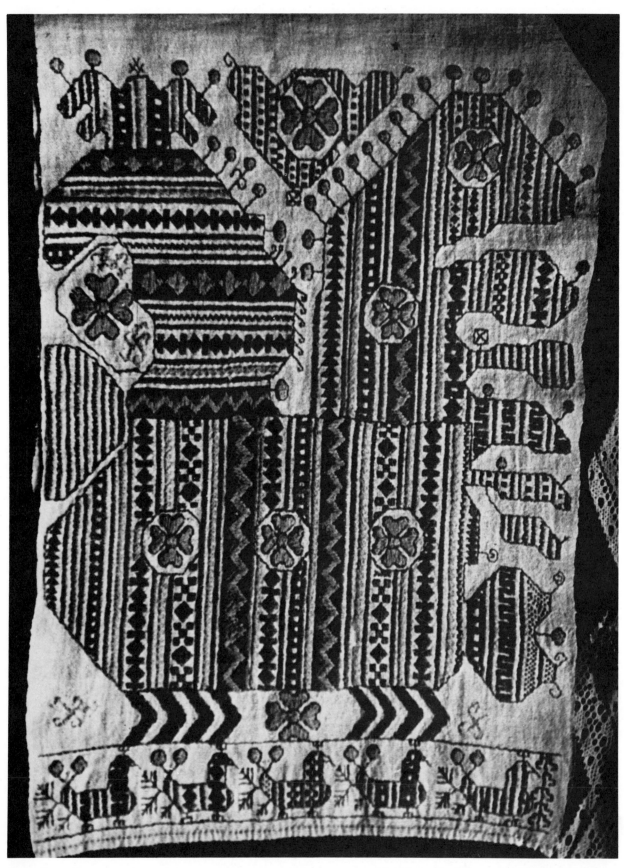

2–24. Snow Leopard, the end of a towel. Made on canvas with "painting" and nabor. Kargopol district, 19th century. (Museum of Folk Art. Photograph by N. T. Klimova.)

Cross Stitch

Cross stitch embroidery began to spread rapidly throughout the Russian countryside in the second half of the 19th century. Cross stitch ornaments are mainly geometric (Figures 2-25 C-8), but sometimes we find birds, flowers, people or even plot pictures (Figure 2-26). Such motifs were usually copied from printed pictures which the embroiderers bought at local fairs. However, traditional geometric designs were usually the best ones. In the north, cross stitch embroidery was done mostly in red, though occasionally black and blue were also used (Figure 2-27). In the Tambov province, such embroidery, worked in silk and adorning headgear and blouses, was multicolored, with terracotta red and dark brown harmoniously combined with azure, ochre, soft green and warm pink shades. A Tembov cross stitch embroidery design is shown in Figure 2-28. The design is worked in three colors: red, yellow and green.

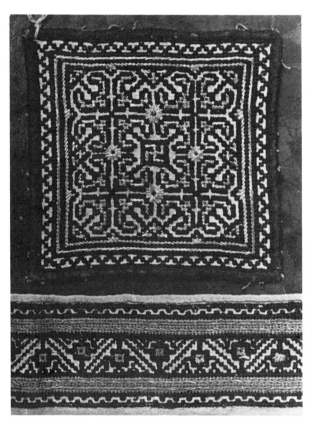

2–25. A fragment of a head towel embroidered with cross stitch. Tambov province, 19th century. (Museum of Folk Art. Photograph by N. T. Klimova.)

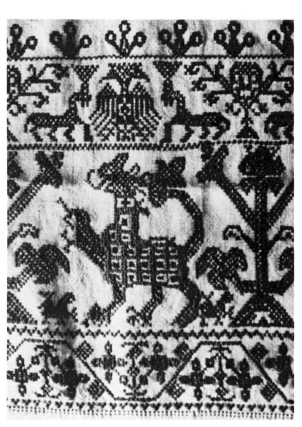

2–26. Fabulous Beasts, a curtain. Made on canvas with cross stitch. Olonetsk province, 19th century. (Museum of Folk Art. Photograph by N. T. Klimova.)

2–27. A design for cross stitch embroidery.

Technique

A cross is made up of two intercrossing stitches of equal length (Figure 2-29). In Russian embroidery, the rows of stitches are usually horizontal or diagonal. The stitching is done in two stages (Figure 2-34A and B). First, a row of stitches, going upwards from left to right, is made to the end of the row, picking up three or four fibers for each stitch. Then, the thread goes back, crossing the previously made stitches with new ones, also covering three or four fibers. Such threadwork results in a row of crosses appearing on the right side of the cloth and a row of parallel vertical stitches on the wrong side. Threadwork for making a diagonal row of crosses is shown in Figure 2-30C; to make vertical rows, see Figure 2-30D.

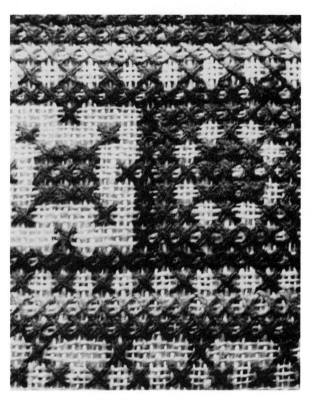

2–29. The cross stitch.

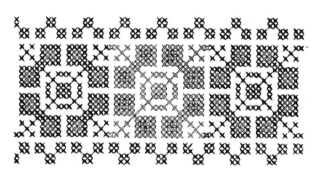

2–28. A Tambov cross stitch design for which red, yellow and green can be used.

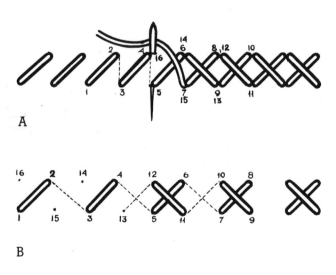

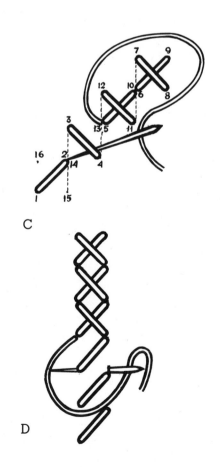

2–30. The cross stitch: (A) one-sided cross stitch, (B) alternating cross stitch, (C) diagonal cross stitch, (D) vertical cross stitch.

Herringbone and Closed Herringbone Stitches

A wide hem of bright cloth, ribbon or tape along the lower border of a red or multicolored ornament was a necessary element in Russian folk embroidery. Such a hem was usually combined with bands of embroidery in which the oblique satin stitch, the herringbone stitch and the closed herringbone stitch were used (Figures 2-31, 2-32).

Technique

Herringbone Stitch. This stitch makes a transparent colored stripe, consisting of sparsely spaced, intercrossing long stitches (Figure 2-32A). The technique of the stitch is as follows. The first diagonal stitch covering four fibers is made downwards from left to right between points 1 and 2. Then the thread is taken back two or three fibers on the wrong side of the cloth at point 3. The second right-side stitch covers the four fibers between points 3 and 4 and goes diagonally upwards from left to right. At point 4, the needle is transferred to the wrong side and comes out again at point 5, and so on. In this way, a design

of intercrossing stitches is formed on the right side, while two parallel rows of horizontal stitches appear on the wrong side in checkerboard order. Sometimes the intercrossing stitches are interwoven with colored thread.

Closed Herringbone Stitch. This consists of stitches of unequal length that seem to be closely plaited and form a broad braid-like stripe. The "braid" (Figure 2-32B) begins with a long oblique stitch connecting points 1 and 2 and going downwards from left to right, after which the needle passes vertically on the wrong side of the cloth from point 2 to point 3. Brought out again, the needle is transferred to point 4 in a short oblique stitch going downward from right to left. From point 4, the needle goes to point 5, making a vertical stitch on the wrong side, after which the threadwork is repeated. Thus, the downward movements of the needle and thread from left to right result in the appearance of long stitches, while the downward movements from right to left produce shorter ones. At the same time, vertical stitches at intervals of two to four fibers are made on the wrong side. The closed herringbone stitch is usually about three to ten fibers wide.

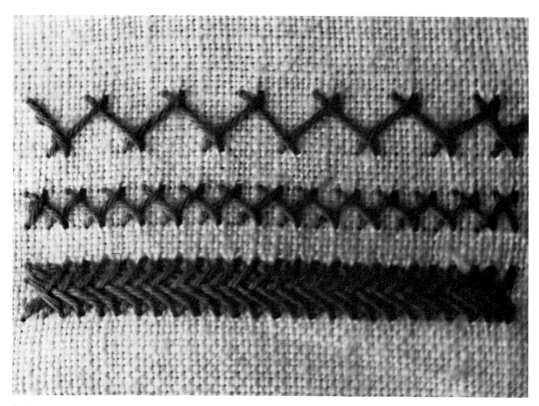

2–31. Herringbone (top *and* middle) *and closed herringbone* (bottom).

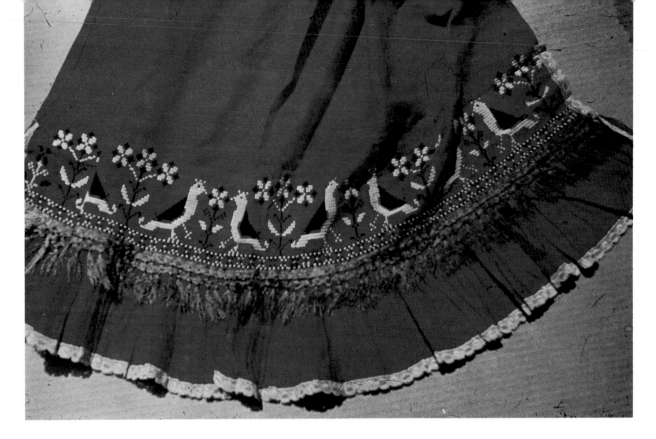

C-2. A 19th century apron (detail) from the Ryazan province. Red calico and silk fringe are used. The embroidery is done with the cross stitch. (The Ryazan Museum of Art.)

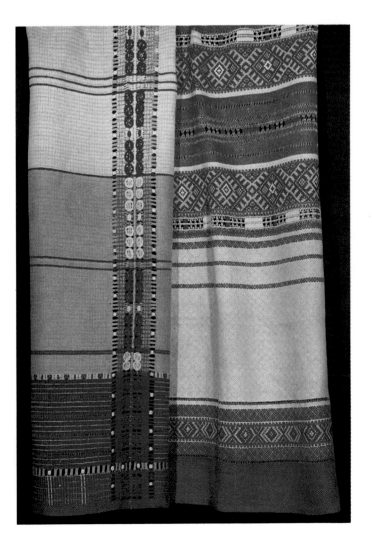

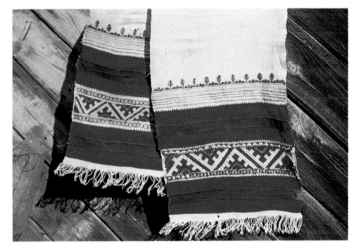

C-4. A towel made of linen and red calico showing weaving, colored meshwork and "painting." Tambov province, the end of the 19th century. (Tambov Museum of Regional Studies. Photograph by N. T. Klimova.)

C-3. Two stoleshniks with decoration in the style of the folk embroidery of the central regions of Russia. Made of flax, with a combination of figured weaving and plain and figured openwork. (Made by L. Romanova and T. Isaeva. The Storehouse of the Scientific Research Industrial Arts Institute. Proceedings of the Scientific Research Industrial Arts Institute, Moscow, 1975, p. 56–73. Photograph by V. K. Voronin.)

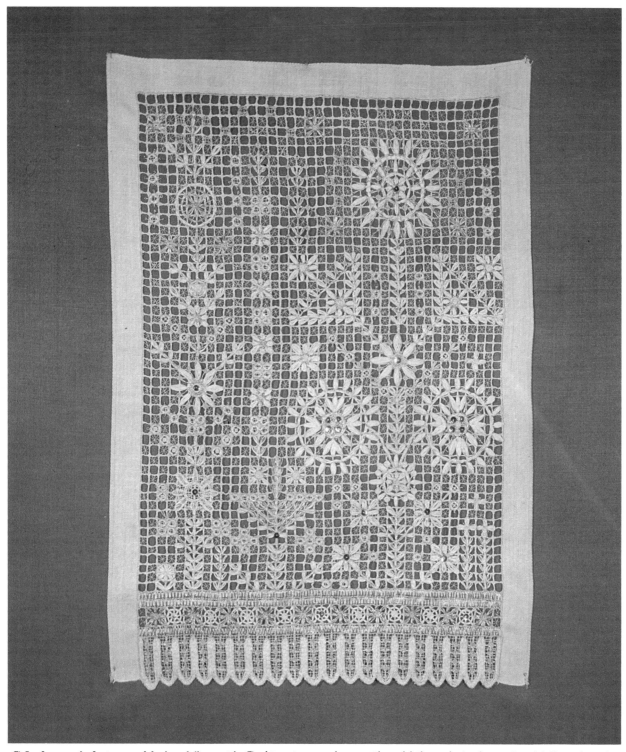

C-5. A panel, Autumn. *Made of flax with Gorki guipures done with gold threads in the style of folk embroidery of the Gorki province. (Made by L. S. Filonova. The Storehouse of the Scientific Research Industrial Arts Institute. Photograph by J. V. Maximov.)*

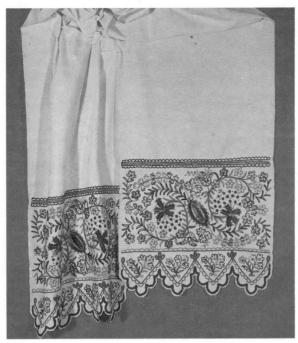

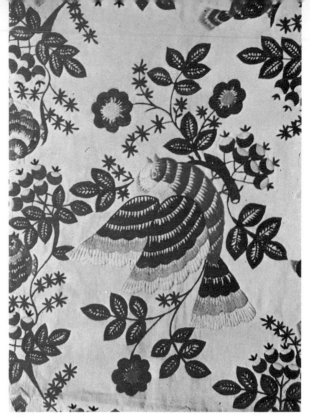

C-6. A towel. Linen with multicolored tambour. Nizhegorodsk province, the beginning of the 19th century. (The property of the author. Photograph by V. K. Voronin.)

C-8. A panel, Fairy Tale. Vladimir stitches done in the style of the folk art of the Vladimir province. (Made by V. Noskova. Photograph by N. T. Klimova.)

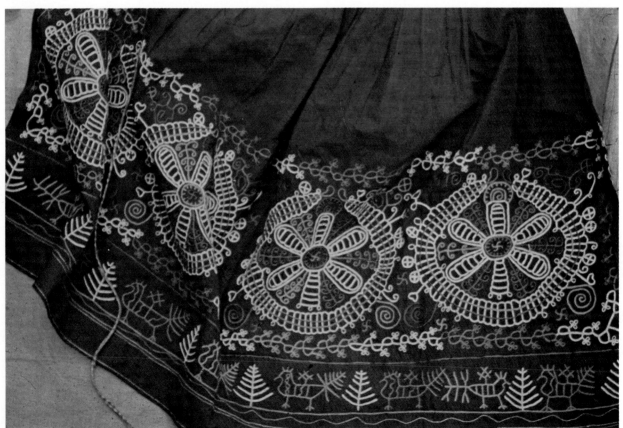

C-7. An apron made of red calico with multicolored tambour. Archangelsk province, the end of the 19th, the beginning of the 20th century. (Museum of the Textile Institute. Photograph by N. T. Klimova.)

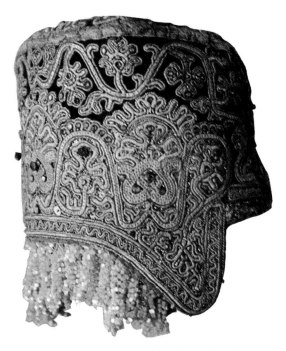

C-9. A woman's velvet headdress with gold embroidery; the podniz is made of cut mother-of-pearl. The end of the 18th, first half of the 19th century. (Museum of Folk Art. Photograph by N. T. Klimova.)

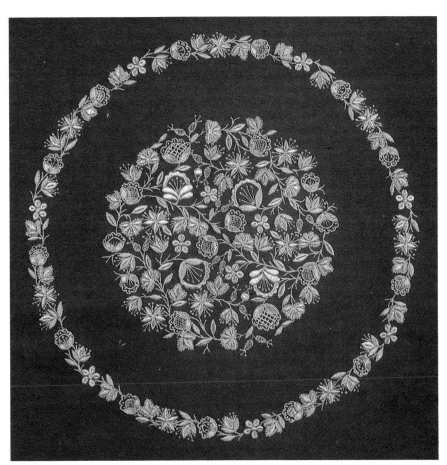

C-10. A decorative silk cushion with gold embroidery in the Russian style. (The work of the students of the Torzhok Professional Technical School. The property of the author. Photograph by N. T. Klimova.)

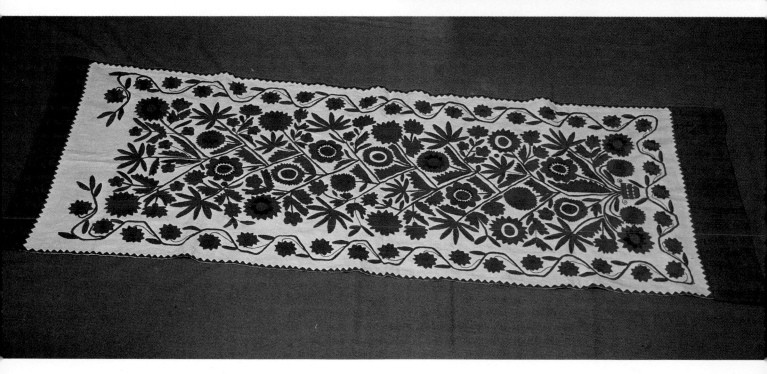

C-11. A 19th century wedding kerchief made of linen and embroidered with the oblique stitch, counted satin stitch and "painting." Chuvash. (From Cheboksary: Chuvash Folk Fine Art, 1960, table XXII. Photograph by A. N. Kurenkov.)

C-12. A linen rushnyk. Satin stitch with fastening is used. Ukraine, Charkiv province, the 19th century. (Museum of Folk Art. Photograph by V. K. Voronin.)

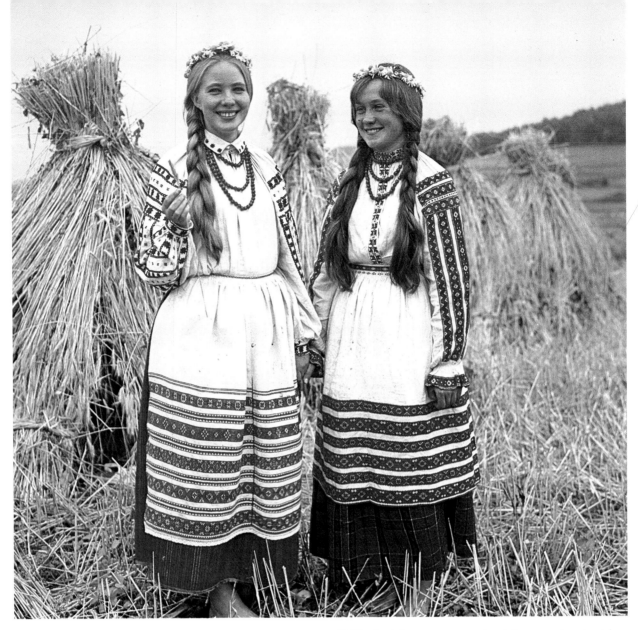

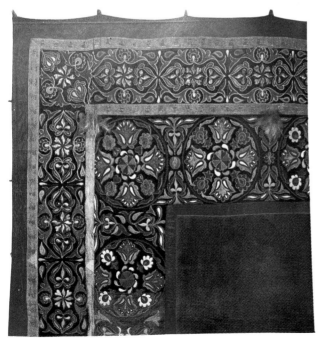

C-13. A girl's costume made of linen and embroidery with figured weaving. Forest areas of Belorussia. (Photograph by M. F. Romanjuk.)

C-14. A wall carpet called tuskiiz (detail). Embroidery is done with tambour on broadcloth. (From Folk Decorative Applied Arts of the Kazakhs, Leningrad, 1970, vol. 34. Photograph by A. N. Kurenkov.)

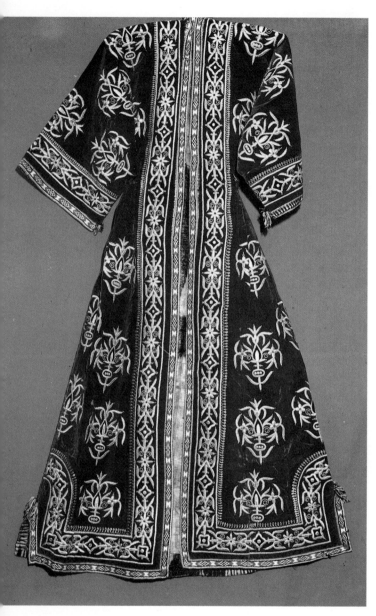

C-15. A woman's velvet dressing gown with gold embroidery. Buchara, Uzbek, the end of the 19th, the beginning of the 20th centuries. (Museum of Folk Art. Photograph by V. K. Voronin.)

C-16. A small carpet made of linen with the three-layer stitch. Dagestan, the 19th century. (Museum of Folk Art. Photograph by V. K. Voronin.)

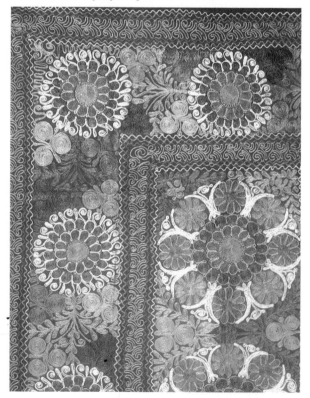

Under-Thread Stitch and Run-Through Stitch

The solid-colored satin stitch or *nabor* embroidery of Southern Russia was often combined with light transparent bands, embroidered with the under-thread stitch (Figure 2-33). The run-through stitch was used in making narrow textural bands of embroidery. These run-through threads not only help vary the texture of the lower hem of an ornament, but also add to the color and texture of the plain cloth background, dividing its upper part into stripes and checks.

Technique

Under-Thread Stitch (*Poddyovchaty*). The stitching is done in two stages (Figure 2-33): first the lower part and then the upper one. To make it easier to follow the threadwork, the cloth is marked with three rows of dots at intervals of four to six fibers. The two lower vertical stitches (1-2 and 3-4) are made, after which the thread comes out on the right side of the cloth at point 5, passes under stitches 1-2 and 3-4, sliding over the cloth, and is transferred to point 6, thus completing the lower part of the stitch. Next, the needle is taken from point 6 to point 1 to make the upper part of the stitch. To pass from one figure to the next, a long stitch is made on the wrong side of the cloth, connecting points 12 and 13, after which the threadwork is repeated.

Run-Through Stitch (*Prodyorzhki*). The technique of this stitch is shown in Figure 2-34. To run thick threads through the weave, one or several adjacent fibers are pulled out of the cloth (Figure 2-34A). Then a thin linen or silk thread, folded in two, is tied to one of the fibers lying loose in the space thus formed (Figure 2-34B). The linen or silk thread is pulled through the cloth, after which a thick band of threads is passed through its loop and pulled through the cloth in the opposite direction with a quick movement. This stitch is often combined with an interlacing or "figure eight" stitch to give the pattern a raised look (Figure 2-34C and D).

Combined with the stitches mentioned in this chapter were ribbons, tape and narrow patterned lustrous braid, in which metallic threads predominated. They adorned *ponyovas* (a kind of skirt), shirts, *navershniks* and *shushpans* (short garments worn over a shirt and a *ponyova*), and other clothes worn by women in the south of Russia. In the northern and central parts of Russia embroidery done in counted stitches combined with ribbons and tape mostly decorated *sarafans* and shirt sleeves. An especially fine example of such decoration is the national costume of the Moscow province (Figure 2-37).

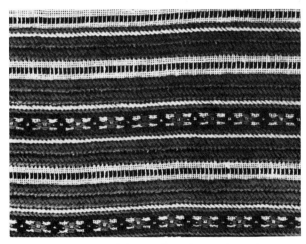

2–35. The design of this embroidery is based on a combination of the closed herringbone and running stitch. (Photograph by V. M. Obukhova.)

2–36. An example of a composition combining plain and patterned textural bands. The embroidery is done in "painting" and closed herringbone stitches. (Photograph by V. M. Obukhova.)

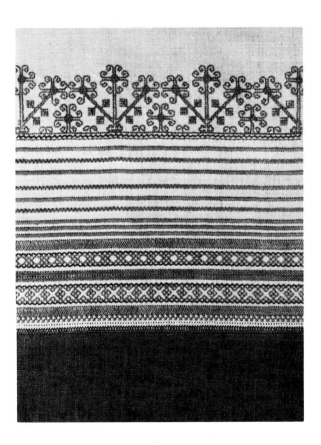

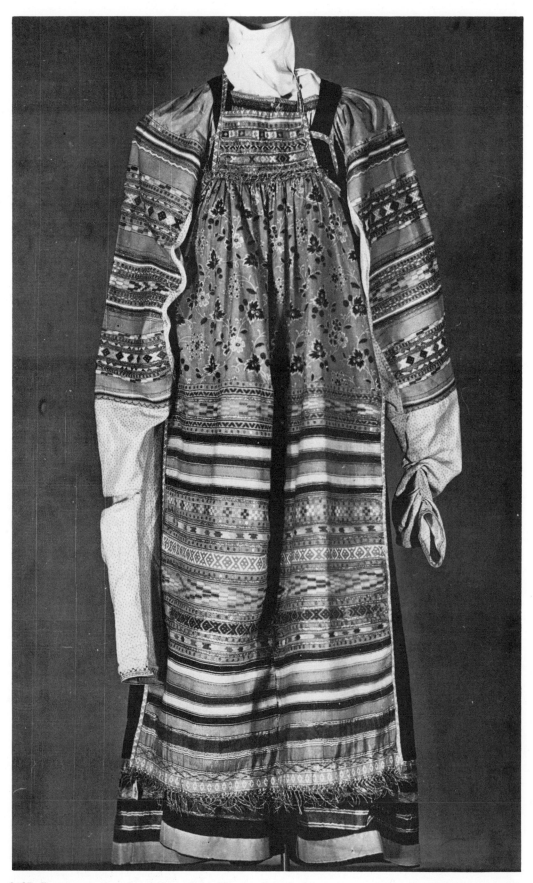

2–37. *Russian national costume of the Vereya district, Moscow province, the 19th century. (Museum of Folk Art. Collection of photographs of the Scientific Research Industrial Arts Institute.)*

Chapter 3

Russian Openwork Stitches

Drawn-Thread Embroidery

Drawn-thread embroidery is executed on even-weave cloth that is prepared by removing a definite number of fibers from the warp and the weft. The resulting bands can be narrow or wide, simple or complex, single-row or multi-row, white or colored. This technique was used together with satin stitch, "painting," *nabor* as well as patterned weaving, bright strips of ribbons and tapes to decorate everyday articles and holiday costumes. This delicate embroidery was used to give the pattern an airy look as well as to enrich the cloth texture.

A series of narrow and/or wide drawn-thread embroidery is often the only decoration on an article. It is delicate, elegant, light and beautiful, and is suitable for decorating table and bed linen, as well as clothing. Articles only decorated with this type of embroidery are made of plain or small-patterned cloth, as well as of checked and striped linen. Figures 3-1 and 3-2 give examples of this type of decoration. In these figures one can vividly see how drawn-thread embroidery is organically included in the woven stripes.

Technique

The first stage in drawn-thread embroidery is preparatory. At this stage one should choose the location of the embroidery on the article as well as the number, width and alternation of the bands in accordance with the intended pattern. Then the fibers are removed according to plan. The second stage is tightening the resulting loose fibers into bundles. The third stage is necessary only if complex drawn thread embroidery is required for decorating the article. Tightened bundles are then covered with a white or colored pattern by means of various interlacings of the working thread.

Tightening Fibers into Bundles

Hemstitch (Brush). This method is used for hems and is combined with other methods in multi-row embroidery. Loose fibers are tightened into bundles on one side only (Figure 3-4A). Two to five fibers are first removed from the cloth near the edge of an article. Then the working thread is fixed near a sewed edge, several free fibers are taken from the thinned band and, after twining them from right to left, they are tightened; this results in a loop. After fixing the loop with the thread, the needle goes forward through two to three fibers of the cloth on the sewed edge and then enters the thinned area for further tightening of loose fibers into bundles. The threadwork is repeated as shown in Figure 3-4A.

Ladder Hemstitch (Column). This method is similar to the hemstitch but the bundles of loose fibers are twined on both sides of the stripe (Figure 3-4B), producing even columns. Depending on the pattern and the texture of the cloth, from three to ten fibers are removed. In narrow ladder hemstitch, not more than three or four fibers are tightened into bundles; in wide ladder hemstitch, however, this number reaches ten or more.

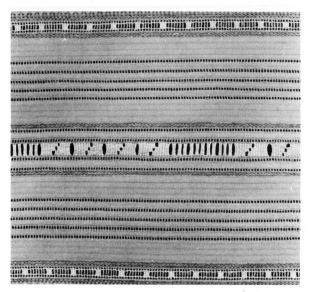

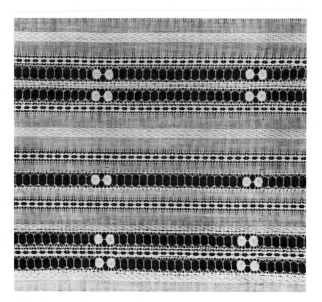

3–1. Stoleshnik *(a small table-cloth) of the Ryazan province. Striped cloth with plain and patterned drawn-thread embroidery. (Made by K. A. Protsenko. From the Storehouse of the Scientific Research Industrial Arts Institute. Photograph by V. M. Obukhova.)*

3–2. *A detail of a blouse from the Novgorod province. Made on cotton striped fabric with patterned drawn-thread embroidery. (Made by K. A. Protsenko. From the Storehouse of the Scientific Research Industrial Arts Institute. Photograph by V. M. Obukhova.)*

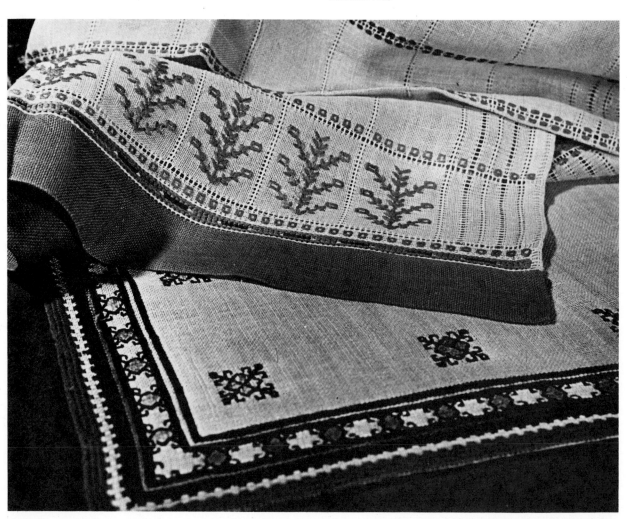

3–3. *Two stoleshniks with the colorful embroidery in the style of the folk embroidery of the southern regions of Russia. (Made by L. G. Begushina. From the Storehouse of the Scientific Research Industrial Arts Institute.)*

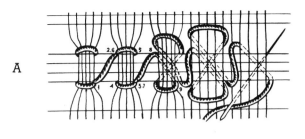

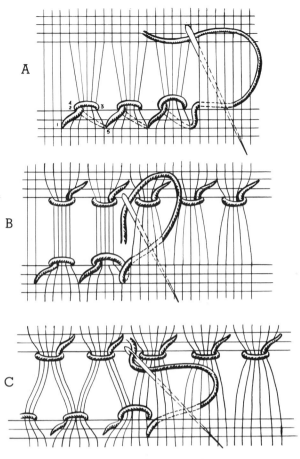

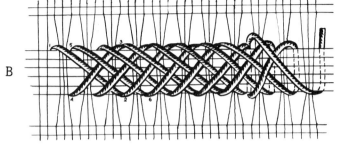

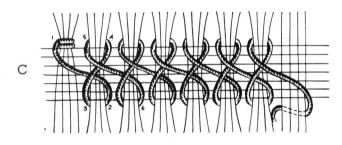

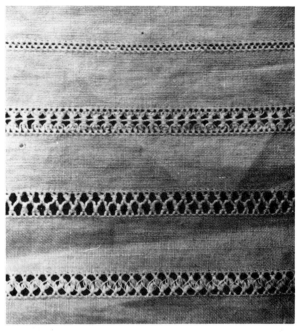

3–4. (A) *Hemstitch,* (B) *ladder hemstitch,* (C) *zigzag hemstitch.*

3–5. (A) *Double hemstitch* (panka), (B) *braid,* (C) *figure eight.*

Zigzag Hemstitch (Split). In this method, one edge of the thinned band is tightened into bundles in the same way as in regular hemstitch. The number of fibers, however, should be even (four, six, etc.). On the opposite edge, half the fibers of the preceding column and half the fibers of the following column are tightened into one bundle, as shown in Figure 3-4C. Thus, each column is split in half.

Double Hemstitch (*Panka*). Fiber bundles are simultaneously tightened into columns in two adjacent thinned bands; this accelerates the process of embroidery. The working thread is fixed between the two bands (Figure 3-5A). Then the needle goes upwards on the face of the cloth (stitch 1-2), passes to the back and turns down to the right (stitch 2-3); then it returns to the face of the cloth at a distance of five fibers and assumes the initial position (stitch 3-4). Next, the needle goes to the back and upwards from left to right, and firmly tightens the lower bundle (stitch 4-5). The needle goes over five fibers of the cloth, from right to left and downwards, to point 7, firmly tightening the bundle. The threadwork is then repeated. Figure 3-5B and C shows two additional methods of tightening bundles.

3–6. *Examples of drawn-thread work. (Photograph by N. T. Klimova.)*

Patterned Drawn-Thread Embroidery

Patterned drawn-thread embroidery can be simple, using one of the patterns for a design, or complex, combining two, three, or even more patterns (Figures 3-12, 3-13).

There are two types of simple-patterned openworks in Russian folk embroidery. In the first group, the spaces between the already made bundles are darned with a pattern. This group includes the "sheaf," the "spider," and the "loop." In the second group, the bundles themselves are embroidered. This group includes the "colored column," "fastening," and "flooring." Each group is characterized by its own decorative qualities and motifs. The first is light, transparent and airy while the second is decorative, bright and thick.

"Sheaf." The "sheaf" is based on tightening several columns in their centers (Figure 3-7A). For this type of embroidery, no less than eight or ten fibers are removed from the cloth. Then, after making columns, the working thread is fixed to the cloth at the beginning of the stripe and, with the help of a running stitch, three columns are alternately taken and tightened together with a loop, as shown in Figure 3-7A. In order to insure that the working thread does not slip and that it lies exactly in the center of the sheaf, two knots are made. In order to avoid the appearance of a horizontal thread between the columns, the working thread is twined, as shown in Figure 3-7B. In this way two, three, or four columns can be tightened. (As the number of columns to be tightened increases, however, the number of fibers that are removed should also increase.)

"Spider." The "spider" is a variation of the "sheaf." Its characteristic feature is a woven "spider" disc located in the center of each sheaf. A "spider" is made by weaving a working thread over and under the threads of the sheaf and tightening it in a knot (Figure 3-7C).

Loop. Three groups of fibers are pulled out from the cloth. For the main pattern, eight to ten fibers are pulled out in the center; two to three fibers are pulled out on each side of this main section to make the narrow auxiliary stripes. The loose fibers are split into columns with a double hemstitch (Figure 3-5A). Then four columns are twined with a working thread in such a way that an airy loop is formed (Figure 3-7D). The working thread is first secured at point 1; then the needle runs left to point 2 and twines two columns, after which it goes upwards to point 3, circles the cloth and goes to point 4, again twining two columns. In order to continue the row of loops, take the working thread and circle the bottom of the cloth for a distance of 5 columns, and begin the entire sequence again.

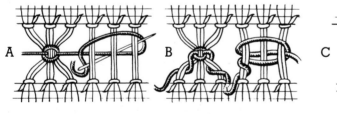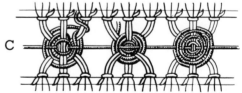

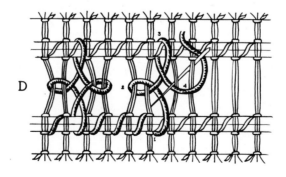

3–7. (A and B) "Sheaf" (two variants), (C) small "spider," (D) loops.

"Colored Column." Ordinary drawn-thread embroidery can be made more colorful if the columns are twined with colored threads (Figure 3-11A). The working thread is secured at the base of the column, is taken upwards and secured at the top; next the thread works downwards, twining the column together. For proceeding to the next column, a horizontal stitch is made at the base (on the back), after which the thread work is repeated. The columns can be twined with one color or with two to three colors.

"Fastening" (*Prikrep*). In this method, five or eight columns are covered with a white or colored working thread (Figure 3-10B). Then, the working thread is twined around the columns and itself. This results is a white or colored square, rectangle or lozenge with small, clear spaces.

"Flooring." This is also based on a column, but the stripe is wider, the number of removed fibers being ten to twelve. Patterns in the form of lozenges, squares and zigzags are made with a darning stitch done in a definite order (Figure 3-10C and D). A white or colored working thread is woven between three columns. Each new row of stitches is pressed next to the preceding one and this results in a thick ribbed surface.

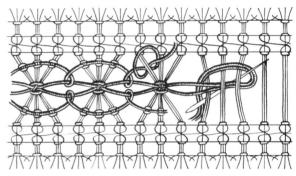

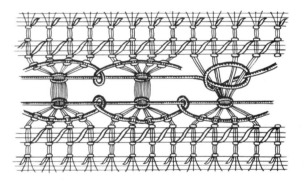

3–10. Patterned drawn-thread embroidery. The top diagram shows the threadwork used in Figure 3–9.

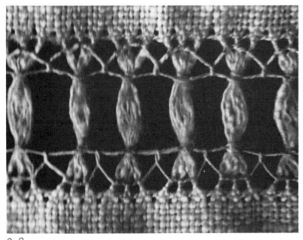

3–8

3–9

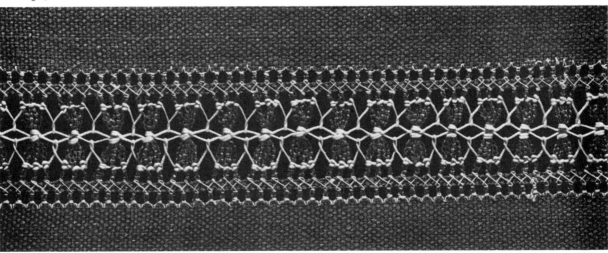

3–8, 3–9. Two examples of patterned drawn-thread embroidery with the spaces between the bundles darned with a pattern. (Photographs by V. M. Obukhova and N. T. Klimova.)

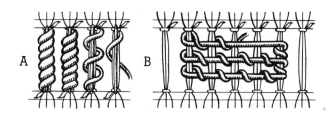

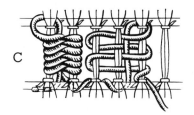

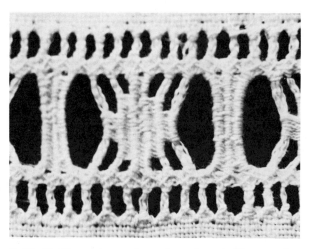

3–12. Multirow drawn-thread work with "flooring." (Photograph by N. T. Klimova.)

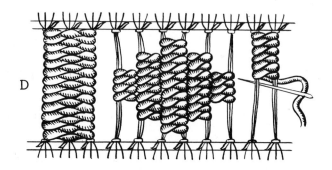

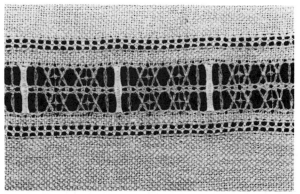

3–11. (A) Colored column, (B) "fastening" (prikrep), (C and D) "flooring" or darning.

3–13. Complex patterned drawn-thread work. (Photograph by V. M. Obukhova.)

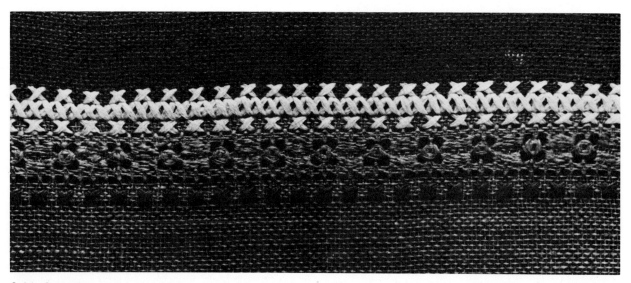

3–14. A masking stitch in which patterned drawn-thread work and cross stitch are combined. (Photograph by V. M. Obukhova.)

Uses of Drawn-Thread Embroidery

This type of embroidery was often used to connect two pieces of cloth as well as to finish edges. In making tablecloths, curtains and runners, two pieces of cloth often had to be connected in order to get the required size. Stitches connecting the pieces were masked with a decorative embroidery organically combined with the main pattern (Figures 3-14, 3-15). Simple ladder and zigzag hemstitches were used together with the satin stitch, the cross stitch and the "braid." For decorating edges of table cloths, towels, curtains, and other embroidered articles, either narrow or wide drawn-thread embroidery bands were used. (A beautiful toothed edge can result if a wide band is worked with columns and is folded in half, as shown in Figure 3-16C.) If the edge is to be colored, the columns are twined with colored threads as far as the middle, and the two adjacent columns are combined in the shape of the letter X (Figure 3-16B). To do this, the working thread is secured at the left edge and the first column is twined with dense stitches as far as the middle. At that point the second column is taken and drawn towards the first one and twined downwards with similar dense stitches. When the work is completed, the band is folded in half and the edges stitched.

If drawn-thread embroidery is done both along the warp and the weft, the intersection makes a square. Embroiderers usually fill the corners of such squares with a beautiful pattern (Figure 3-16A). The threadwork is shown by the position of the needle.

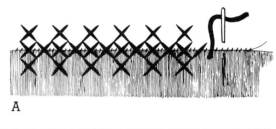

A

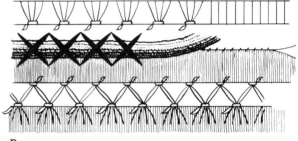

B

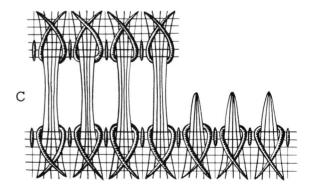

C

3–15. Masking stitches: (A) cross stitch, (B) hemstitch and zigzag hemstitch with cross stitch covering the cord and the place where the two cloths are connected, (C) decorative drawn-thread work and satin stitch.

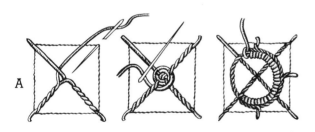

A

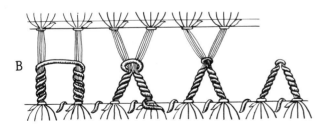

B

3–16. (A) Filling in intersections of warp and weft, (B and C) finishing the edges of a cloth with the help of drawn-thread embroidery.

C

Meshwork

The mesh forms the second large group of Russian openwork. It is done on a "mesh" that has cells of different sizes. These are prepared by removing a definite number of fibers from the cloth along the warp and the weft. It was used mostly in the central districts of Russia. The Russians used meshwork for adorning everyday and holiday clothes: shirts, aprons and towels used as headdresses. It was most prominently used in decorating mourning clothes. Beautiful towels, bed curtains and *stoleshnicks* (tablecloths) were also decorated with meshwork. Needleworkers of some northern and central provinces of Russia also added plain and patterned drawn-thread embroidery and sewed bobbin lace along the edge of the article. However, the snow-white pattern on clothes and everyday linen was most often combined with colored overstitches: delicate "painting," rich satin stitches and *nabor*. This complicated pattern was supplemented with raised, patterned weaving and with multicolored stripes of bright cloth, ribbon and tape, where red, dark blue and green colors prevailed.

Meshwork is divided into three large groups:
1. Simple meshwork
2. White meshwork
3. Colored meshwork

Each group is characterized by its own range of motifs and unique pattern textures.

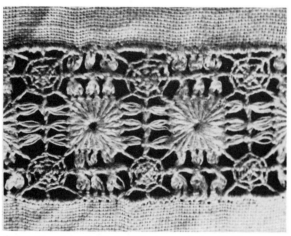

3–17. The "star" stitch. (Photograph by N. T. Klimova.)

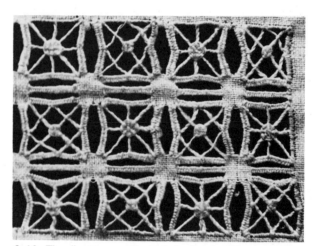

3–19. The "cutting-out" stitch (tarlata). (Photograph by N. T. Klimova.)

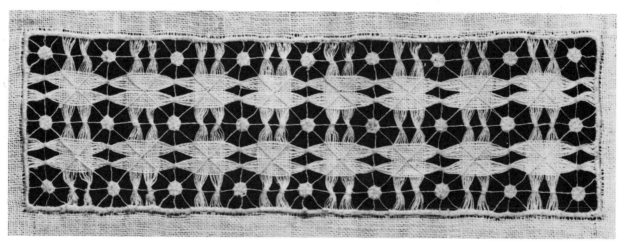

3–18. The "fly" stitch. (Photograph by V. M. Obukhova.)

Simple Meshwork

For this kind of embroidery, one should use only linen cloth of calico weave, with uniform closeness along the warp and the weft so that fibers can easily be removed.

The execution of the embroidery includes three main stages:

1. Pulling out fibers from the cloth to form the mesh;
2. Overstitching the edge of the motif (before or after securing the mesh); and
3. Making the pattern on the mesh.

Making the Mesh

Before pulling out fibers from the cloth, it is necessary to outline the location and size of the motif; this may be a square or a rectangle or, more rarely, a lozenge or some other geometric figure. To do this, the outlined contour is basted with a running stitch. Next, a fiber outside each of the outlined edges is drawn out (Figure 3-20A). After this, the number of fibers that must be removed along the warp and weft in order to make the cells must be computed. The fibers to be removed from the cloth are then cut near the edge of the motif (Figure 3-20B). The middle fiber is the first to be pulled out; fibers adjacent to it are removed in pairs. Fewer fibers should be pulled out of the rows near the edges because the cells adjacent to the edges of the motif will grow in size when the edges are overstitched.

Overstitching the Edges

Before or after entwining the columns of the mesh, the edges where fibers have been cut are overstitched (Figure 3-20C and D). These overstitches should be closely spaced.

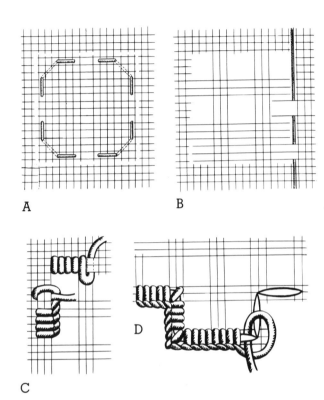

3–20. Meshwork preparation: (A and B) pulling out fibers from the cloth, (C and D) overstitching the edges.

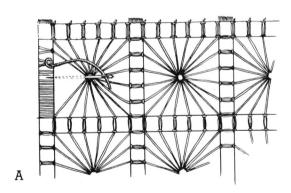

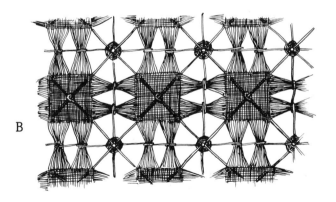

3–21. Meshwork patterns: (A) "star," (B) "fly."

The Pattern

The "Star." This is an ornament of checks filled with a raised pattern resembling a radiant star. It is a decorative, smart and simple technique, based on ordinary ladder hemstitch drawn-thread embroidery, with fibers tightened into bundles in a specific manner. To get a checked pattern, fibers are pulled out from the cloth along the warp and the weft, the ratio of fibers left and pulled out being ten to four or six respectively. As a result, one gets a cloth surface divided by the bands of loose fibers. The loose fibers are then tightened in bundles. To do this a small hole, in the center of the squares formed, is pierced. The working thread is passed through this hole each time the columns are formed (Figure 3-21A). After tightening a bundle of loose threads in a loop, the needle goes through the hole and then to the following bundle, on the back. After passing around three sides of a square, proceed to tighten the bundles of the second square, and so on. The threadwork is repeated. Columns along the outer edge of the stitch motif are tightened in the last turn.

The "Fly." The number of fibers pulled out and left in this case is equal: 16 by 16, 20 by 20, etc. After the fibers are pulled out, through the angles of the squares of the cloth left diagonal small bases are made which intercross in intersections as shown in Figure 3-21B. Then the bundles are tightened in the center of loose threads with a knot of the working thread. In cutting diagonal small bases the working thread is also intercrossed, forming a small knot. After all the bundles are done a dense circle in the form of a "spider" is formed in the center of each square. Another variant of such folk embroidery is the formation of bundles out of loose fibers with the help of airy loops that fill the gaps of the openwork squares.

Cutting-out Stitch. For this kind of embroidery (Figure 3-22A), six or ten fibers are pulled out along the warp and the weft. It should be pointed out that columns for such a mesh must have an even number of fibers left: four, six, or more. They are densely twined with a darning stitch, using white or colored threads. The darning can be twofold or threefold. When the darning is twofold, the needle goes into the middle of a column, alternately taking half of the threads over the needle and half of the threads under the needle; later this order is reversed. The stitches of the working thread are worked close to each other, forming a ribbed surface. The cells of the mesh are filled with a light pattern: an airy loop, or a "spider," for example.

These patterns often form lozenges, triangles, squares or other geometric forms on the mesh.

Kubanetz. The simplest *kubanetz* is made up of a small square cut out of the cloth; the edges of the square are surrounded with a geometric pattern using satin stitch (Figure 3-24). The clear space of the square is filled with diagonals at whose intersection different patterns can be worked (Figure 3-22B and C).

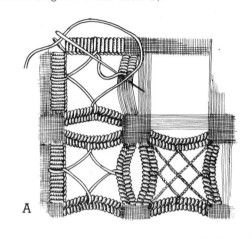

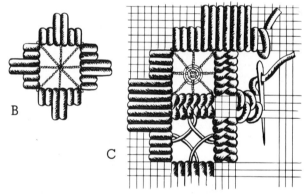

3–22. (A) Cutting-out, (B and C) kubanetz.

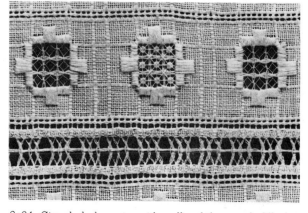

3–24. Simple kubanetz with cells of the mesh filled with an airy loop and a copeck. (Photograph by V. M. Obukhova.)

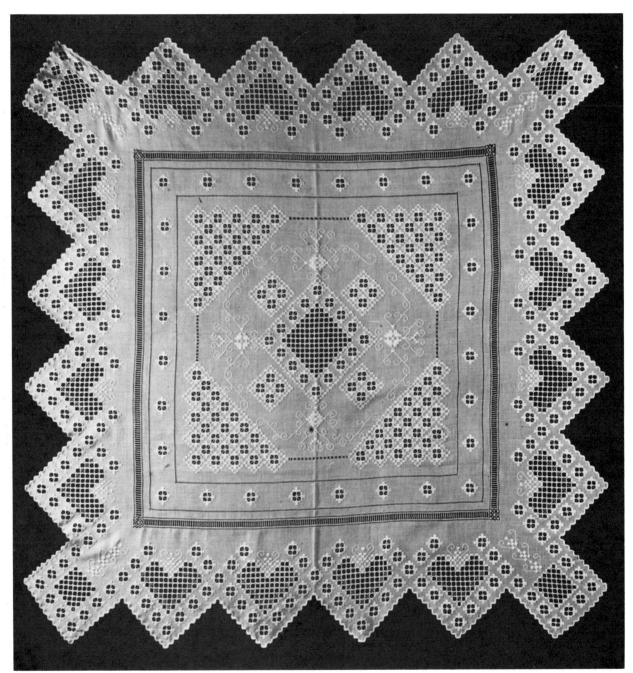

3–23. An example of the embroidery of the Ivanov province. Made on linen with kubanetz, *drawn-thread embroidery and counted satin stitch. (Made by A. T. Bushueva. From Rabotnova and Yakovleva:* Russian Folk Embroidery, *Moscow, 1957, table 48. Collection of photographs of the Scientific Research Industrial Arts Institute.)*

White Meshwork

White meshwork is the largest group of folk stitch embroidery. As with the "painting" stitch, white meshwork enables the embroiderer to make various motifs: geometric and floral forms, birds and animals, architecture, people, etc. (Figure 3-25). White meshwork is widely used for decoration of different articles: clothes, bed and table linens and decorative articles. It is well known to the embroiderers of the Ivanov, Kaluga and Kalinin regions. They often combind white meshwork and patterned drawn-thread embroidery.

White meshwork is worked on an even mesh having small square cells, the columns of the mesh being intertwined with a thin white thread. The pattern, unusual in its diversity and textural beauty, is embroidered on this fine mesh. The white stitch is begun by calculating the number of mesh cells on graph paper; after this the fibers are pulled out according to plan.

Pulling Out Fibers

According to the character of the embroidery and the structure of the cloth used, pulling out fibers for the formation of the mesh is done along one or two sides. On thin cloth, threads for the mesh are pulled out along one side (either the warp or the weft). In doing so, rows are formed with an interval of three or four fibers (four fibers pulled out, four fibers left, for example). After this, loose fibers of each thinned band are tightened into bundles: the outside bundle with a hemstitch, the middle bundles with a double hemstitch. The columns are so located that they form one line. For heavier cloth, fibers for the mesh are pulled

out along both sides of the warp and the weft so that they form a square. Square cells are necessary to avoid the distortion of the proportions of the picture that will later be embroidered on this mesh. If fibers of the warp and weft are of the same thickness, an equal number of fibers, say three by three, is pulled out. If the fibers of the warp and weft are of different thicknesses, one more of the thinner threads is taken out (say three by four). Usually, the number of fibers pulled out equals the number of fibers left, but if one wishes to get a more transparent background, the number of fibers pulled out is increased by one (for example, four fibers are pulled out and three fibers are left).

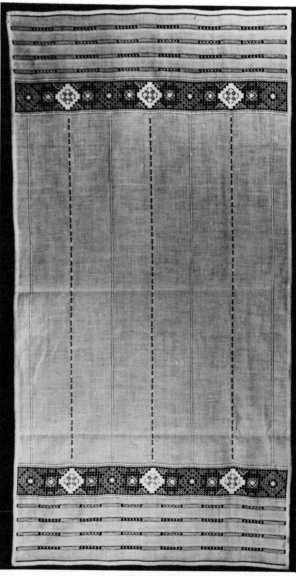

3-26. A stoleshnik *from the Ivanov province. Made on linen with white meshwork and patterned drawn-thread embroidery. (Made by N. Kiseleva. The Exhibition Fund of the Scientific Research Industrial Arts Institute. Photograph by V. M. Obukhova.)*

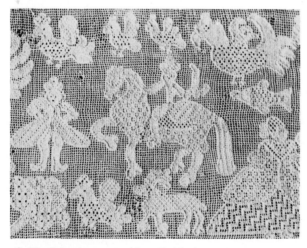

3-25. A bed curtain (detail). Made with white meshwork with figured patterns. Vologda and Petersburg province, the end of the 18th and the first half of the 19th centuries. (Museum of Folk Art. Photograph by N. T. Klimova.)

Twining the Mesh

The pattern can be done on untwined mesh. More often, however, after forming a mesh, the cloth is pulled over an embroidery hoop for twining columns. For white meshwork, the columns of the mesh are twined with a thin white thread. To avoid the distortion of the pattern when the embroidered article is washed, the mesh is twined along the diagonal. (See Figure 3-29A for the method of twining.) The edges are then over-stitched.

The Pattern

The mesh, twined and overstitched along the edges, forms a background for embroidering. For the pattern, soft threads such as mouline, silk or wool are used. Folk embroiderers have worked out a great number of different texture stitches for outlining the pattern on the mesh (Figure 3-26).

"Flooring." This fills the mesh cells completely. The working thread, twining the columns, fills in the checks with dense parallel rows in horizontal and vertical directions (Figure 3-29B and C). Cells may be filled with an intertwined thread that runs one or several times from one edge of the motif to the other. The result is either a bulging, uneven texture or an even surface, slightly raised above the background. In flooring, the upper and lower columns of the mesh are taken by the needle in turn: one over the needle and the other under the needle. On the return of the working thread, the columns are taken by the needle in reverse order.

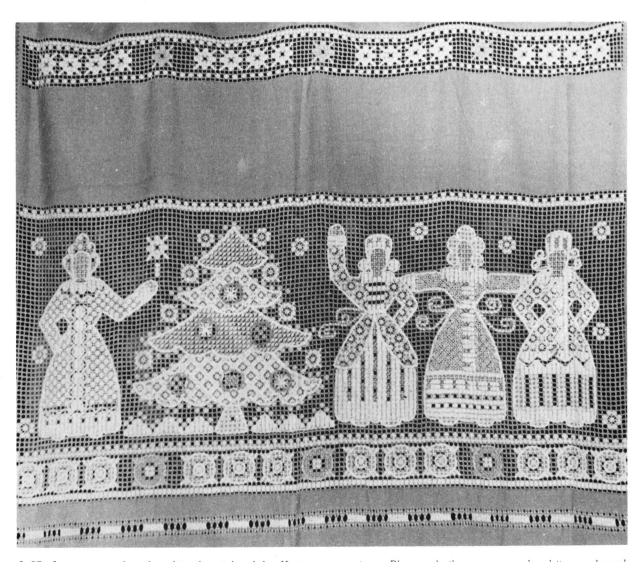

3–27. A curtain embroidered in the style of the Kostroma province. Blue and silver grey wool, white meshwork and drawn-thread work. (Made by K. A. Protsenko. The Storehouse of the Scientific Research Industrial Arts Institute. Photograph by V. M. Obukhova.)

"Fastening." Here the working thread twines the mesh columns in two directions: horizontal and vertical. A straight cross is formed in each cell of the motif and the even surface of the ornament has small though clear spaces. For threadwork, follow the Figure 3-30A (begin by securing the working thread on the back, near the lower left edge of the motif). If fastening is worked on transparent cloth having fine meshes, thin sewing thread should be used. If it is worked on thick, dense cloth, soft threads should be used.

Diagonal "Fastening." This fills in mesh cells from one angle towards the other along two diagonals. As a result of such threadwork, an oblique cross is made in each check. Diagonals are made in the same way as in regular fastening; that is, parallel threads are laid and then twined as shown in Figure 3-30C.

Airy Loop. The airy loop fills in the mesh cells with a light and transparent lacy pattern (Figure 3-30B). It is worked with thin sewing thread. This threadwork results in the formation of a quadrangular net whose ends are fixed to the mesh columns.

"Spider." The "spider" is made in the same way as *kubanetz* (Figure 3-22C). Diagonal as well as vertical and horizontal lines are made in each

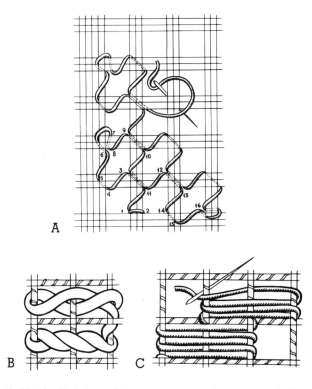

A

3–29. (A) *Twining of the mesh along the diagonal,* (B *and* C) *two variants of the "flooring" stitch.*

3–28. *White meshwork on an intertwined mesh with "flooring," darning and flexible outlines. (Photograph by N. T. Klimova.)*

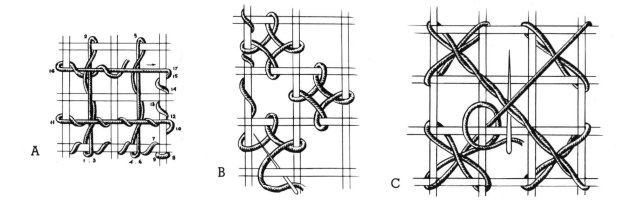

A B C

3–30. (A) *"Fastening,"* (B) *loop,* (C) *diagonal "fastening."*

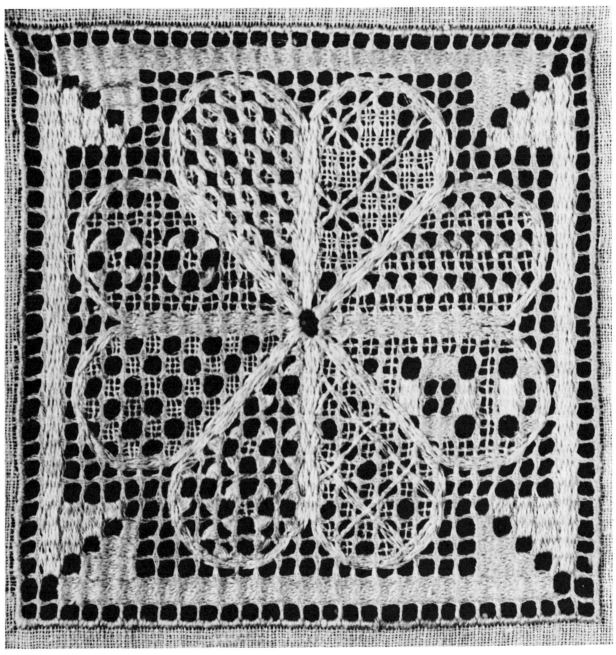

3–31. Complex stitch patterns. (Photograph by V. M. Obukhova.)

cell of the mesh with the working thread. Then, in the center of the intercrossings of these threads, a small flat circle is made. To do this, the working thread twines each of the threads by turn in a weaving pattern.

The stitches described above are basic in making the stitch pattern. Flooring and fastening densely fill in cells, resulting in a smooth bulging surface. Airy loops make a light transparent pattern. Circles of "spiders" surrounded by diagonal rays introduce additional rhythms and new movement to the embroidery. All these patterns combined in a single piece produce an unmatched harmony of texture.

Colored Meshwork

In the past, colored meshwork was very popular in the Tula, Orel, Kaluga, Tver and Smolenks provinces. This openwork counted embroidery is also worked on a mesh formed by pulling out fibers from the cloth along the warp and the weft, but its cells are of smaller sizes. What is more, the intertwining of the mesh between white motifs of the ornament is done with colored threads that densely twine each column and intercrossing.

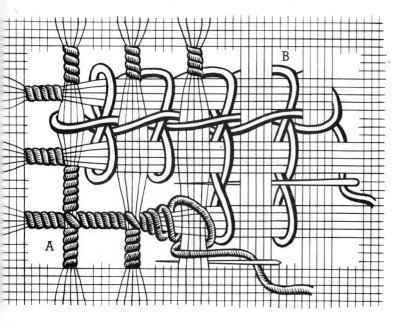

3–32. (A) *Twining the mesh with a colored thread,* (B) stlan *on the untwined mesh.*

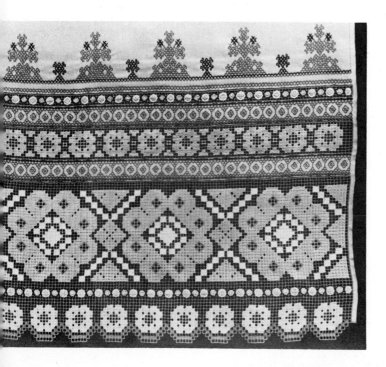

The general coloring of embroidery was extraordinarily diverse and depended upon how the mesh was twined. Embroiderers in the Ryazan, Tula and Kaluga provinces preferred to use bright red or quiet claret colors; in the Smolensk province, bright yellow or dull orange; in the Tver province, raspberry; in the Orel province, golden-green (C-4).

In colored meshwork, the main ornament is geometric, with different configurations of lozenges, triangles and stars dominating (C-4), but in some provinces figurative motifs were popular as well. The embroideries using the colored mesh technique, unusual in their beauty, adorned holiday headdresses, shirts, aprons and wedding kerchiefs. The colored mesh embroideries were used alone but most often they were used in combination with plain and patterned woven stripes, raised embroideries done in overstitches, patterned ribbons and tapes (C-4).

In working the colored mesh, one should remember that the mesh is denser than in the white stitch. For this reason, more fibers are left than pulled out from the cloth (for example, three fibers are pulled out and five fibers are left). The pattern is made on an untwined mesh with white, soft threads. The empty spaces of cells are filled so that a very dense surface resembling an unbroken cloth is formed. This technique of embroidery is called *stlan*. The *stlan* is made with single darning or with "flooring" as in the white meshwork (Figure 3-32B). After making the pattern, the mesh left on the background is densely intertwined with a thread of red or any other color. The intertwining of the mesh can be done along diagonals or straight rows. The edge of the mesh is fastened with colored threads or loop stitch.

Besides white meshwork and the colored mesh, at the end of the 19th century in Russia there appeared two more types of meshwork: the Gorki guipure and Krestsy stitch. They are named after the location of their origin.

3–33. *Example of colored meshwork with "painting" stitch. (Made by V. V. Hrumkova. The Storehouse of the Scientific Research Industrial Arts Institute.)*

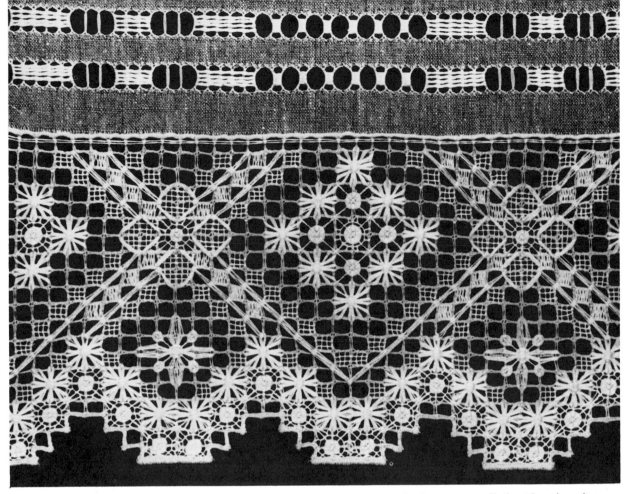

3–34. A tablecloth (fragment) in the style of the folk embroidery of the Gorki province. Embroidered on linen with Gorki guipure. (Made by K. A. Protsenko. The Storehouse of the Scientific Research Industrial Arts Institute. Photograph by V. M. Obukhova.)

The Gorki Guipures

This technique of embroidering was formed at the end of the 19th century in the Nizhnegorodsk province (now Gorki district). It is the embroiderers of Katun, Balachna and Liskov who used this technique most often.

The characteristic feature of the Gorki guipures is a mesh with thin columns and large cells of up to one centimeter in size; as a result, the whole embroidery was more transparent and airy than the traditional white stitch. Embroiderers used patterns that were well-known in the white stitch and were also characteristic of this kind of embroidery. Long stitches forming fluffy "floorings" highly raised above the background were basic in this technique of embroidery.

The stitches that formed the basis of different motifs of the Gorki guipures were: a *baburka* made with a single thread, a *minutka* having the form of a transparent flower with four petals, fluffy eight- and sixteen-petal flowers, different kinds of rosettes and stars. Raised fluffy motifs were combined with a flat *kopeck* in the form of a

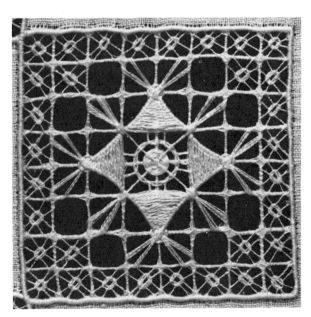

3–35. Stitch square with Gorki guipures used for embroidery of tablecloths, curtains and other decorative articles. (Photograph by V. M. Obukhova.)

dense circle or a lozenge, with a "ring" or a pyramid in the form of a dense triangle. They enabled the folk embroiderers to create patterns of wonderful beauty.

As mentioned above, the Gorki guipures are executed on a large mesh. The mesh for a given embroidery is formed the same way as for white meshwork. Depending on the density of the cloth and the character of the pattern, one should pull out from eight to fifteen fibers along the warp and the weft, three to four fibers being left. Columns of the mesh are twined diagonally and the edges of the stitch motif are then fixed.

The Krestsi Stitch

This is one of the most complicated types of the Russian folk meshwork embroidery. As with the Gorki guipures, this type of embroidery is characterized by both an unusual variety of geometric motifs based on the rhythm of straight and rounded lines and on the beauty of the texture. But there are no long fluffy stitches in this type of embroidery. Everything is intertwined resulting in a clear-cut, snow-white pattern distinctly seen against the background of a large mesh. As with the Gorki guipures, this technique was formed in the second half of the 19th century. It was started in the Novgorod and Volgograd provinces. Here white stitches and cuts were organically combined with the technique of Italian needle lace for decorating fashionable costumes and different articles for the interior. Folk embroiderers learned the technique of needle lace when they had to embroider articles for town buyers. Patterns of the Krestsi stitch resemble delicate, beautiful forms of the geometrical snowflakes and the cascades of hoar-frost of the northern Russian winter. This impression is given by both the outline of the motifs and the unusual texture of the embroidery which looks like it was woven of the finest threads. Here the traditional "flooring," darning stitch, kopeck and airy loop are combined with a peculiar loop stitch that creates a light semitransparent pattern which is never met in other districts. The characteristic feature of the Krestsi stitch is the fact that the mesh for a pattern has both the same (as in the white stitch and Gorki guipures) and different numbers of fibers pulled out and left, depending upon the requirements of the picture. For large motifs the pattern is made on specially-done small bases that are located according to an intended picture.

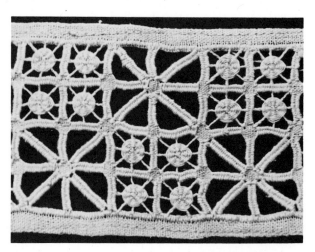

3–37. The Krestsi mesh. (Photograph by N. T. Klimova.)

3–36. A curtain (detail) made in the style of the folk embroidery of Novgorod province. Made of voile, it shows the Krestsi stitch and decorative drawn-thread embroidery. (Made by J. Ch. Fedorova. The Exhibition Fund of the Scientific Research Industrial Arts Institute. Photograph by V. M. Obukhova.)

Chapter 4

Russian Free-Form Stitches

In Russian folk embroidery, there are stitches that are not connected with the cloth texture. These are curvilinear, free-form stitches, usually worked on a contour drawing. They include the tambour, stem stitch, and satin stitches.

Tambour

The *tambour* stitch is a chain stitch. It is only at the beginning of the 19th century that Russian embroiderers began using the *tambour* stitch independently on a pattern; before that time, it was used together with other stitches. It served as decoration for holiday costumes and household linen: towels, shirts, aprons and other articles (C-6, C-7). Most often the patterns were worked in red, but sometimes they were multicolored. Olonetsk embroiderers introduced satin-stitched insets into the linear *tambour* pattern of red or white. These insets sparkled like small lights among fine laces. Vologda and Nizhnegorodsk embroiderers depicted the drawings with smooth lines as well as with lines that made intricate loops. The colors of these lines created a complex rhythm of ochre-golden, deep aqua, and fiery orange tones (C-6). In the city of Novgorod, the *tambour* lines, joining each other row by row, filled in basic ornamental forms. They created floral patterns in which red, green, blue and golden tones predominated. Multicolored rosettes

with roundish petals were surrounded by lacy patterns of thin, transparent small branches. *Tambour* embroidery that decorated the muslin sleeves of women's holiday costumes was especially delicate (Figure 4-1). Embroiderers liked to depict birds and animals, horses and hosemen, well-dressed ladies and cavaliers. However, each individual technique of executing a pattern demanded that the embroiderers treat a given figurative motif in a particular way (Figures 4-5, 4-6).

Technique

Hand *tambour* can be done with either a needle or a hook. *Tambour* worked with a needle is flat, while the chain made with the hook (called *tamburok*) is raised. Having secured the working thread on the back of the cloth, it is taken out to the front; then a loop is made. Holding the loop with the left-hand thumb, direct the working thread to the back of the cloth, piercing the needle into the previously-made hole (Figure 4-7A). For the next loop, the needle is taken to the front of the cloth in such a way that it pricks the exact middle of the previous link. If a wider *tambour* line is required, wider loops can be made. In transferring the working thread from the front to the back, the needle pierces a nearby hole rather than going into the previously-made one (Figure

4-7B). So on the face we have a continuous chain consisting of small loops; on the back we get a continuous line of small stitches, or a dotted line.

As mentioned previously, this stitch can be worked with a *tamburok*. The metallic part of the hook is usually short; this is to keep the depth to which the cloth is pierced uniform. When using a hook, the left hand, which holds the working thread, should be under the cloth while the right hand over it. To make the loops, the hook is stuck into the cloth and then pulled up, as shown in Figure 4-7C.

Stem Stitch

The stem stitch also forms a thin raised line on the cloth; it resembles a narrow twisted cord and is used for making thin, flexible stems and sprouts in floral ornaments and for creating contours for large motifs in any pattern.

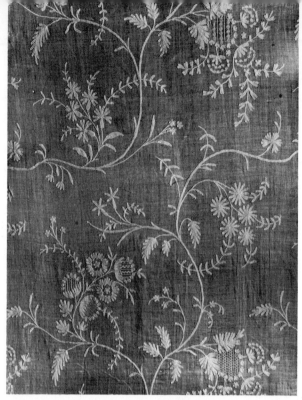

4–1. The sleeve of a woman's beautiful shirt (detail). Made on muslin with white tambour. *Central regions of Russia, the 19th century. (Museum of Folk Art. Photograph by N. T. Klimova.)*

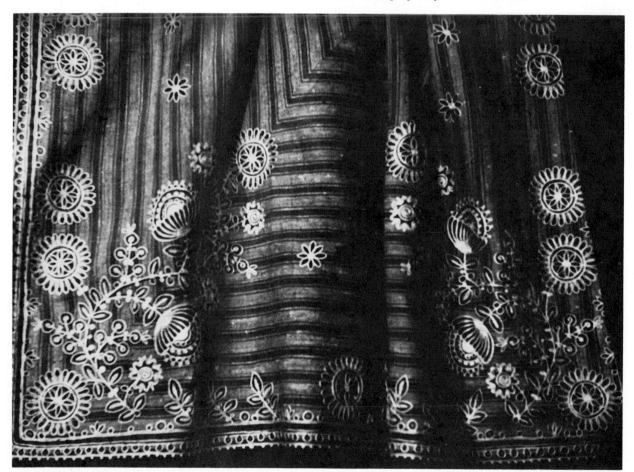

4–2. A tablecloth made in the style of the folk embroidery of the central regions of Russia. Embroidered on striped cloth with tambour. *(Made by N. V. Simakina. The Storehouse of the Scientific Research Industrial Arts Institute. Photograph by N. T. Klimova.)*

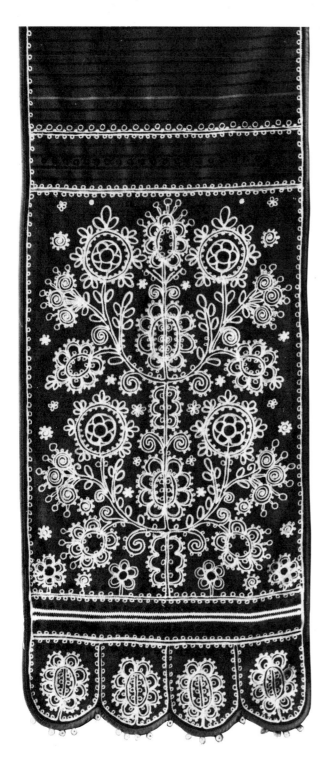

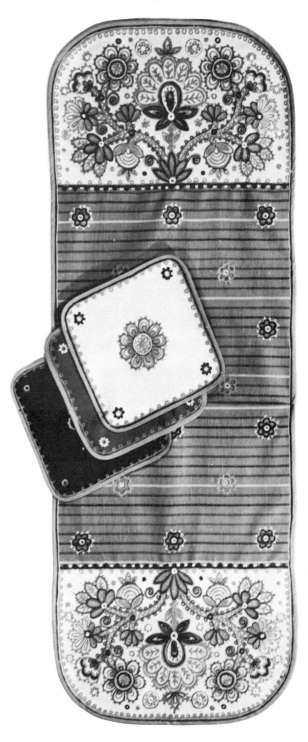

4–3. A towel made of striped cloth and embroidered with tambour. (Made by L. S. Filonova. The Exhibition Fund of the Scientific Research Industrial Arts Institute. Collection of photographs of the Scientific Research Industrial Arts Institute.

4–4. A stoleshnik (table cover) with napkins made in the style of the folk embroidery of the northern regions. Striped and white cloth embroidered with tambour. (Made by L. S. Filonova. Museum of Folk Art. Photograph by V. M. Obukhova.)

4–5. A design for tambour.

Technique

The stem stitch is worked closely together. The first stitch is worked as follows: having secured the thread pierce the needle from back to front making a stitch. Then holding the needle with the point directed to you, pull the working thread to the back. The second stitch is longer than the first one, the needle going out of the cloth in the middle of the previous stitch, and so on. In this way you get a line in which stitches are worked one behind the other, as shown in Figure 4-7E and F. In the process of embroidering, the working thread may be on the left or on the right side of the needle; whichever is more convenient for the embroiderer.

Stitches Combined

Both the *tambour* and the stem stitch, which create raised lines on the cloth, form the basis for two types of Russian folk embroidery in which free-form stitches are combined with counted stitches. These are *tambour* with meshwork and the Orel *spis*.

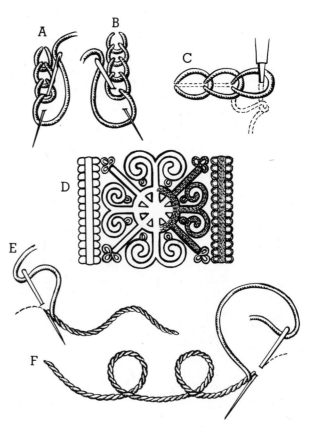

4–6. Another design for tambour, *this one taken from the motifs of the folk embroidery of the Archangelsk province. It is done in red thread on the light cloth, and in white threads on the plain linen.*

4–7. (A *to* D) Tambour *made with a needle and a hook,* (E *and* F) *stem stitch.*

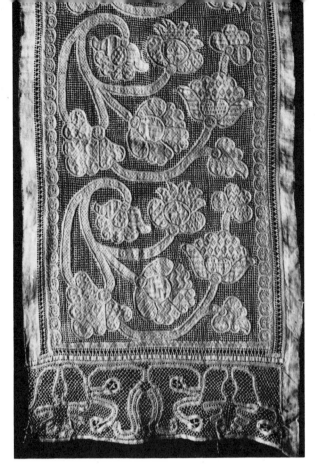

4–8. A bedcurtain made of linen and worked with bobbin lace, tambour on the mesh. Vologda province, the 19th century. (Museum of Folk Art. Photograph by V. M. Obukhova.)

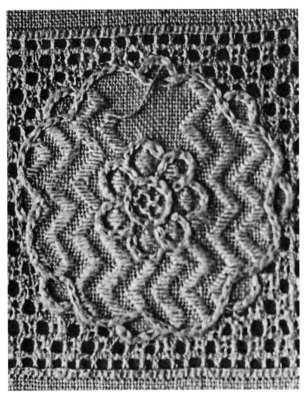

4–9. Tambour on meshwork. (Photograph by N. T. Klimova.)

Tambour with Meshwork. This is a combination of openwork and overstitches. These embroideries were very popular in the north of Russia, especially in the Olonetsk, Vologda and Archangelsk provinces. They were most often used for embroidering bed curtains. The background is comprised of fine, even cells; projected against the openwork texture background are blossoming flowers and elongated leaves (Figure 4-8), palaces, well-dressed ladies and cavaliers, hosemen or carriages carried by swift horses. Lustrous white satin-stitched patterns in the forms of triangles, lozenges or squares often alternate with the openwork (Figure 4-9). Because of the complex play of light and shade in the patterns, the white color of the embroideries has an infinite number of different shades. All this taken together creates a unique decorative effect of lightness, elegance and internal power.

Orel *Spis.* This was used not only by Orel embroiderers, but by the embroiderers of the other provinces as well; but it is in Orel that it was most often used. Towels, tablecloths and sometimes hems of shirts were decorated with this rich, red embroidery. The contour of the motifs has smooth and roundish outlines; it is made with the *tambour* or the stem stitch. The figured patterns are done with the so-called *branki* stitch, which is a variety of the *nabor* (Figure 4-12). The variety of these patterns is endless. Their combination in one pattern creates a very rich texture, either with a dense red color or with gaps of white linen. Sometimes the portion embroidered in red includes dark blue, which diversifies the range of the pattern, increasing its decorative expressiveness.

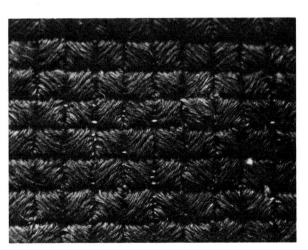

4–10. A variety of counted satin stitch. (Photograph by N. T. Klimova.)

Satin Stitch

In Russian folk embroidery there are several varieties of this stitch, namely the simple satin stitch, the sparse satin stitch, the ancient Russian satin stitch, Vladimir stitches and white satin stitch.

In the 18th and 19th centuries, embroidery in the satin stitch technique was widespread in the Ivanov, Vladimir, Moscow and Nizhnegorodsk provinces. Today, satin stitch is used on simple linen and cotton fabrics, dense and light silk, transparent gauze as well as on modern fabrics. The ornament preferably includes flowers resembling bluebells, tulips, dahlias, pinks, roses, different berries and fruit, but in a characteristic Russian interpretation. Artists and embroiderers often place small birds among the flowers and fruit.

Each kind of Russian folk satin stitch has its own range of motifs and its characteristic features in the execution of the pattern, but all of them are based on small, tightly-fitting stitches.

Russian Satin Stitch. In the Russian satin stitch, the stitches are placed in rows in a checkerboard order; they form a grainy surface on the cloth. This stitch is combined with different patterns and meshes that adorn the centers of large and small flowers as well as bird feathers.

Russian satin stitches are made with a "needle-forward" stitch from one edge of a motif to the other, over ten to twelve fibers, under two to three fibers. On the way back, the stitches fit closely to the previous row. In order to get the even, grainy surface of a motif, all the stitches should be of equal size and end exactly in the middle of the previous stitch (Figure 4-15A). There are many variations of patterns that can be made in the Russian satin-stitch technique; two of them are shown in Figure 4-15B and C. The thread work is shown in the diagrams.

Vladimir Stitches. Since olden times, embroiderers of the Mstera village in the Vladimir region have made bright decorative embroideries using white threads. Against an even-grained background of linen, flexible stems with large decorative flowers and leaves sparkle with bright red shades of long, raised stitches. Introduced into the red range of the basic pattern are golden, blue and emerald tones that fill in small motifs or mark out small centers of large flowers. Such embroidery was used primarily for decorating towels, bed curtains and tablecloths with which the villagers of Mstera and other places in the Vladimir province adorned their houses on holidays.

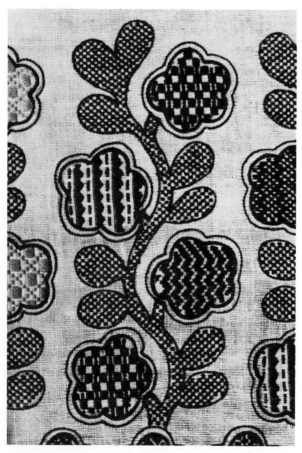

4–11. The Orel spis (detail). (Photograph by V. M. Obukhova.)

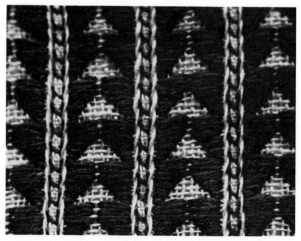

4–12. A branka, a variety of nabor. (Photograph by N. T. Klimova.)

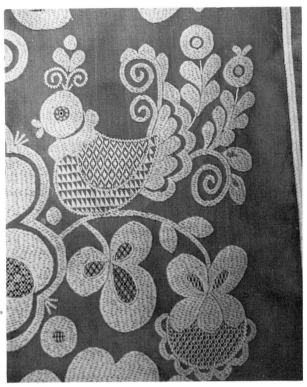

4–13. A fragment of a towel made on flax and embroidered with Russian satin stitch. (Photograph by N. T. Klimova.)

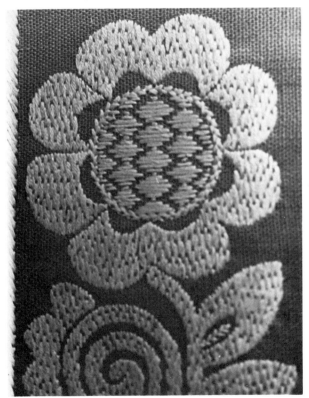

4–14. Russian satin stitch. (Photograph by N. T. Klimova.)

If the pattern is going to be done on white cloth, bright red, yellow, blue and green threads should be used for embroidering. If the cloth is colored, the threads should be selected according to its tone.

Vladimir stitches are one-sided decorative satin stitches. A thick muline working thread fills in each form of the ornament with long stitches on the face; short lines along the contour of the pattern are formed on the back. For flowers, the stitches usually run from the center to the edge in the shape of a fan. For leaves, the stitches run diagonally in two directions from the middle to edges. By alternating short and long stitches, we get a beautiful toothed contour for each motif, as shown in Figures 4-19 to 4-21.

The centers of flowers are often decorated with decorative meshes (Figure 4-15). These meshes are done in two ways. In one method, the inter-crossings of long threads stretched along the cloth are fastened with a small cross or a half-cross (Figure 4-19B). In the other, the centers of flowers and large motifs are filled in with a simple pattern using the counted satin stitch technique. The background gaps may also be filled in with different stitches.

The contours of narrow, rounded parts of the drawing are embroidered in stem stitch or in the oblique satin stitch technique (see Figure 4-19C).

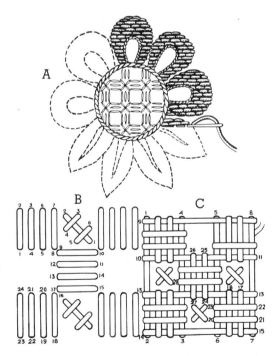

4–15. (A) Russian satin stitch, (B and C) decorative meshes.

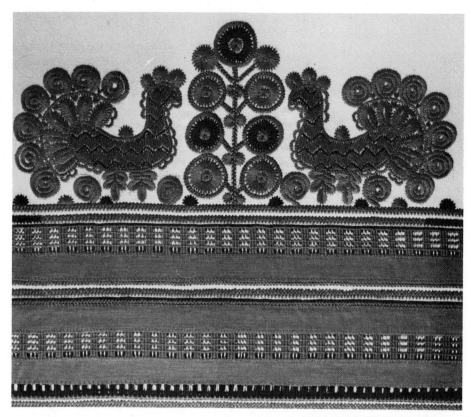

4-16. The end of a towel made in the style of the folk embroidery of the Vladimir province. White and colorful linen cloth embroidered with Vladimir stitches and decorative openworks. (Made by L. S. Pilonova. The Storehouse of the Scientific Research Industrial Arts Institute. Photograph by V. M. Obukhova.)

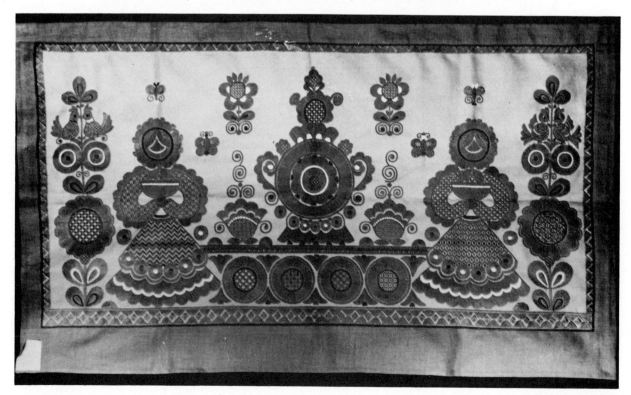

4-17. Tea-drinking, a panel made in the style of the folk embroidery of the Vladimir province. White and colorful linen cloth embroidered with Vladimir stitches. (Photograph by V. M. Obukhova.)

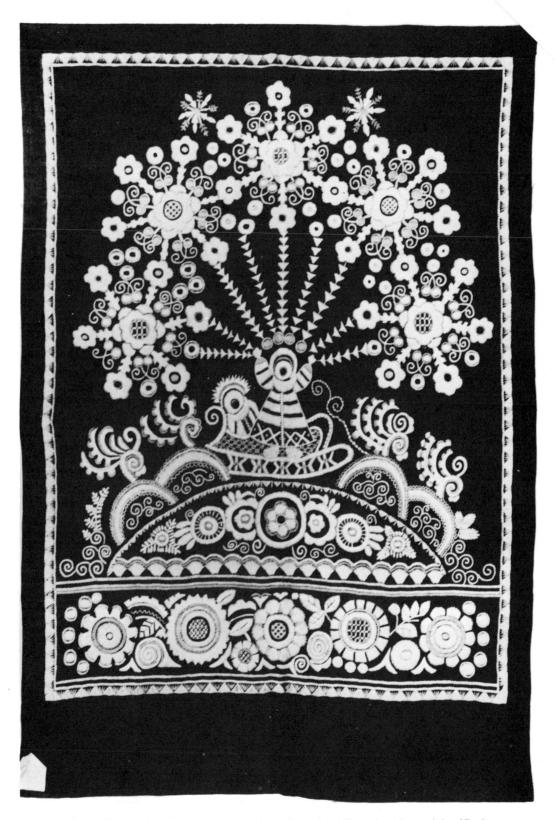

4–18. I'll Drive You to the Tundra, *a panel based on the folk embroidery of the Vladimir province. Vladimir stitches. (Made by T. M. Dmitrieva-Shulpina. The Exhibition Fund of the Scientific Research Industrial Arts Institute. Photograph by V. M. Obukhova.)*

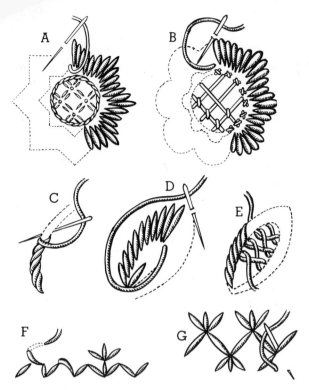

Patterns embroidered in the Vladimir stitch technique are often hemmed with decorative texture stripes and openwork (Figures 4-16, 4-20). They are supplemented by a "brush" stitch, as shown in Figure 4-19F and G.

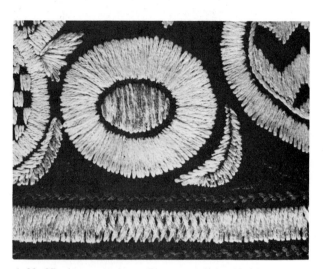

4–19. Vladimir stitches: (A, B, D and E) the one-sided satin stitch, (C) the oblique satin stitch, (A, B, and E) decorative meshes, (F and G) "brush" stitch.

4–20. Vladimir stitches. (Photograph by V. M. Obukhova.)

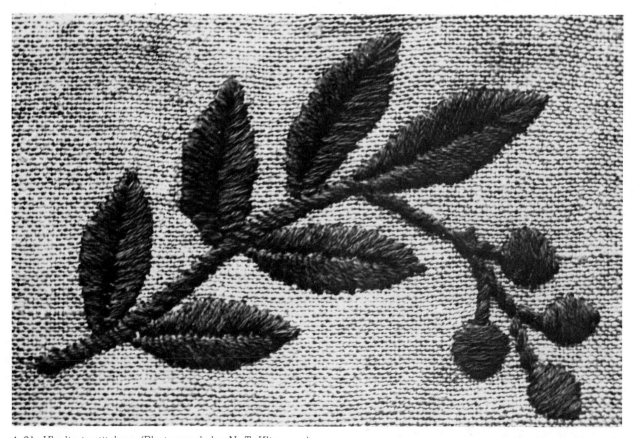

4–21. Vladimir stitches. (Photograph by N. T. Klimova.)

The embroidery is done in two stages. First, along the whole length of the pattern, a part of a middle zigzag line is done using stitches which slant to one side. Going back, the working thread covers the gaps of the zigzag line and simultaneously makes "brushes" alternately above or below it. In making each brush, first outer stitches and then middle stitches are made. Only after this, intermediate stitches are made, if they are necessary to the pattern.

Simple and Sparse Satin Stitches. The simple and sparse satin stitches were known to many folk embroiderers of the central region of Russia. They were attracted by the possibility of embroidering floral patterns with freely-placed flowers and leaves whose surfaces played in the light. Such embroideries were especially popular in the Nizhnegorodsk, Jaroslavl, Kostroma, Vladimir and Moscow regions. They were used for decorating towels, bed curtains, women's shirts and aprons.

Shown are two patterns for embroidering in the simple and sparse satin stitch technique. The pattern in Figure 4-25 is characterized by bright, rich or delicate tones, while the pattern in Figure 4-26 is white with the addition of light-colored pastel shades.

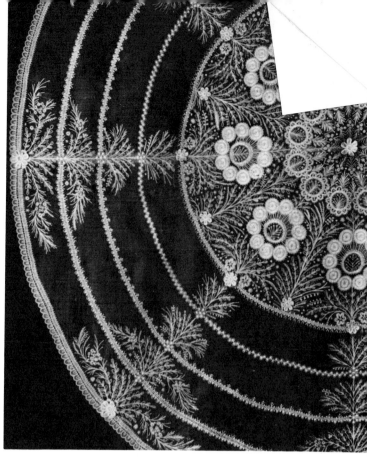

4–23. A tablecloth made in the style of the folk embroidery of the central regions of Russia. Silk and gauze embroidered with simple satin stitch. (Made by L. S. Filonova. The Storehouse of the Scientific Research Industrial Arts Institute. Photograph by V. M. Obukhova.)

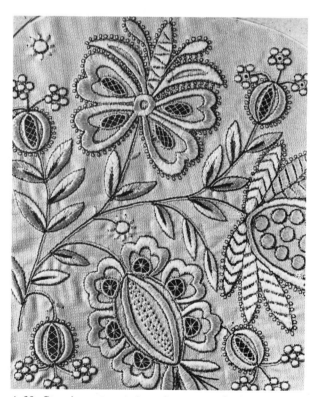

4–22. Simple satin stitch with openworked patterns of the Gorki province. (Photograph by V. M. Obukhova.)

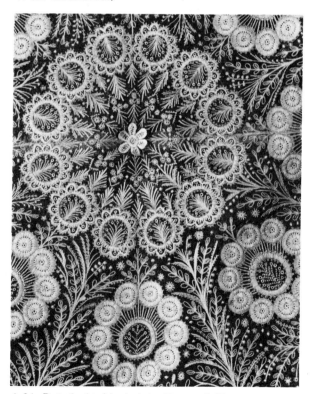

4–24. Detail of tablecloth in Figure 4–23.

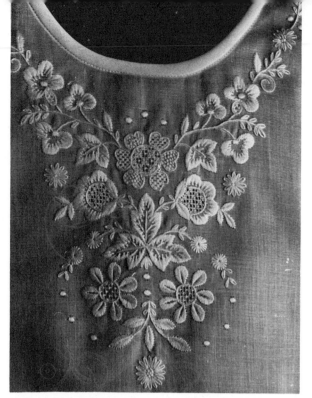

4-28. A blouse (detail) made in the style of the folk embroidery of the Vladimir province. Voile embroidered with white satin stitch. (Made by N. M. Kotkova. The property of the author.)

White Satin Stitch

At the end of the 19th century, in the villages Mstera of the Vladimir region and Cholui of the Ivanov region, there was formed a unique technique of embroidery that was given the name of "white satin stitch." The basis of this delicate embroidery was a simple and sparse satin stitch, combined with English and artistic white stitch, which were very popular in Russian towns in the second half of the 19th century. In those towns, the white satin stitch with openworked patterns was used for adorning women's and children's linen blouses, bedding, tablecloths and napkins. After they began to embroider articles for town consumers, Mstera and Cholui embroiderers adapted their stylish stitches, and gradually created their own unique floral ornament enriched by the beauty of a raised texture. Folk embroider-

4-29. The New Year, a child's bed cover made in the style of the folk embroidery of the Vladimir province. Voile embroidered with white satin stitch. (Made by T. M. Dmitrieva-Shulpina. The Exhibition Fund of the Scientific Research Industrial Arts Institute. Photograph by V. M. Obukhova.)

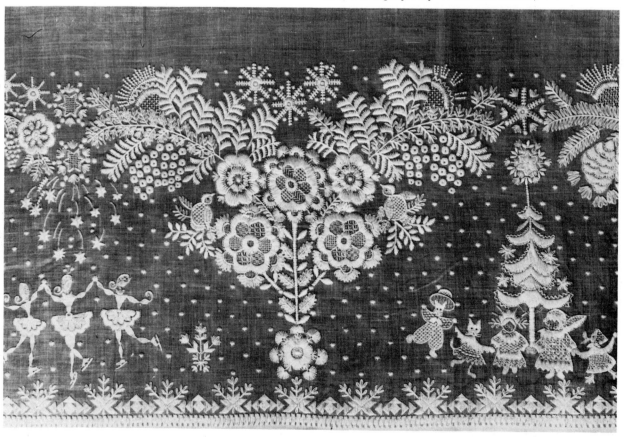

ers greatly developed the technique of the white satin stitch. They combined raised and smooth stitches; introduced an intertwining of stitches that created a grainy surface on the motif; supplemented dense motifs with openwork motifs. They preferred the traditional floral pattern; on thin cloth they embroidered white roses, narcissus, tulips and other garden flowers. Besides floral patterns, they embroidered genre scenes, showing well-dressed ladies and cavaliers, swans, fantastic birds, castles, and so on.

Gradually, embroideries in white satin stitch become popular not only on articles for sale in towns, but for the houses of the embroiderers themselves.

This kind of embroidery is done on white cloths. It is most effective on thin cloth such as cotton marquisette, muslin or silk chiffon, on which a contrast between a transparent background and a dense ornament is created. Very soft, thin white threads are used for this kind of embroidery. Figures 4-28 through 4-32 show beautiful examples of this delicate stitch.

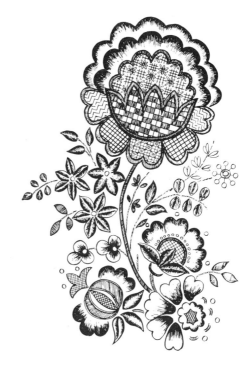

4–30. A design for white satin stitch taken from the motifs of the folk embroidery of the Vladimir province.

A

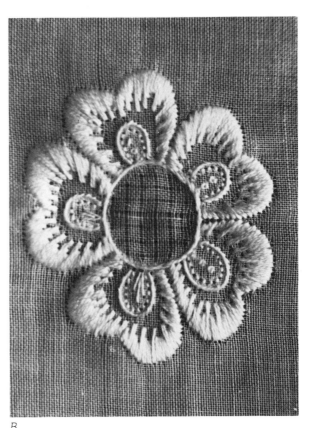

B

4–31A and B. The sequence of making the white satin stitch. (Photograph by N. T. Klimova.)

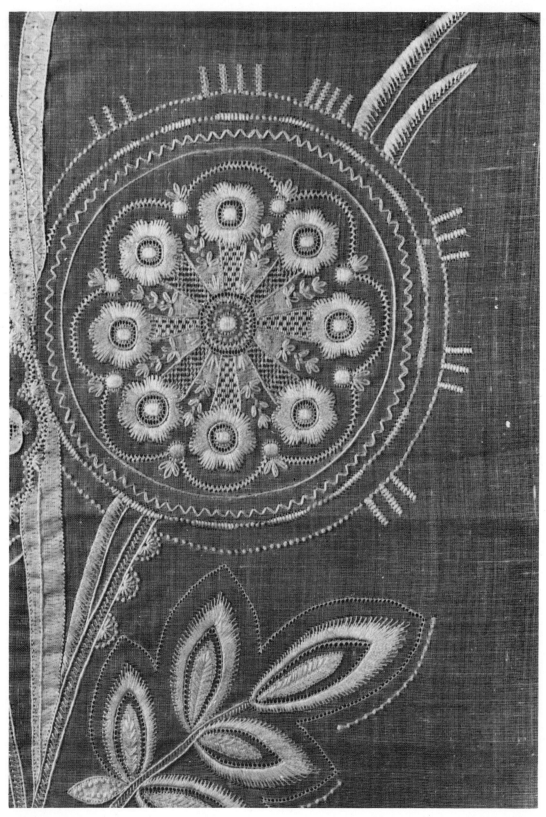

4–32. Complex flowers and leaves made with white satin stitch. (Made by N. M. Kotkova. Photograph by V. M. Obukhova.)

Appliqué

An appliqué is a less time-consuming way of embroidery allowing the use of different colored cloths for making a pattern. Appliqué was widely used by folk embroiderers. They included plain and figured colored stripes. Appliqué in combination with different kinds of overstitches is used for decorative articles (Figures 4-33, 4-34).

The appliqué is done in the following way. First drawings are outlined on background cloth. Then, according to the drawing, each motif (leaves, flowers, stems, etc.) of the pattern is outlined on available colored cloths and then cut out. The motifs of the pattern cut out of the colored cloths are applied to the basic background according to the pattern and basted with the "needle forward" stitch. After this the motifs of the colored cloth are edged, fixing them to the basic background. For this purpose a *tambeur* stitch, free satin stitch or a loop stitch is used. To edge the motif you should use threads either corresponding to the color of the appliqué piece or contrasting to it.

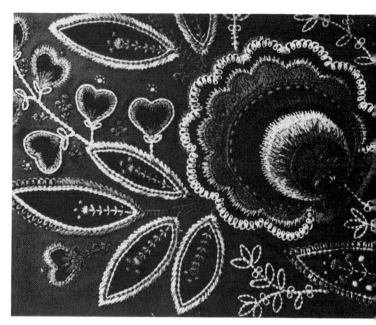

4–34. Detail of cushion in Figure 4–33.

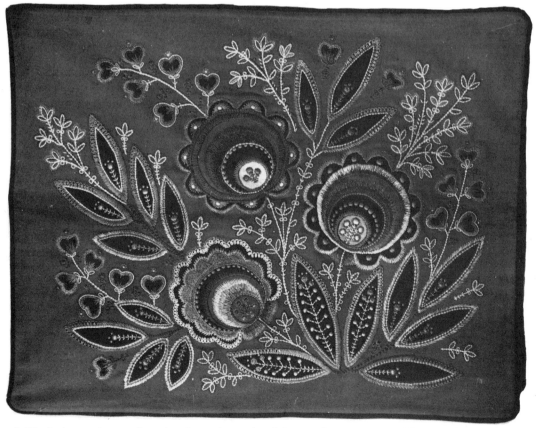

4–33. A decorative cushion made in the style of the southern regions of Russia. Appliqué and overstitches on broadcloth. (Made by T. Ignatieva. Collection of photographs of the Scientific Research Industrial Arts Institute. Photograph by N. T. Klimova.)

Golden Embroidery

Embroidery with metallic threads and stringing pearls is rightfully considered to be one of the most beautiful and complex forms of the Russian folk embroidery.

The art of golden embroidery has been known in Russia from time immemorial. Glittering patterns of precious materials were used for decorating cloths, decorative objects for the home and holiday horse harnesses. The ornament was of floral or geometric character. In the 18th and 19th centuries a precious pattern of golden and silver threads in combination with cut mother-of-pearl, colored glass, spangles and foil was widely used for the decoration of folk holiday clothes, especially girl's and women's headdresses (see C-9).

Such precious headdresses were supplemented by light silk kerchiefs with golden embroidery, lined jackets of velvet and glittering brocade cloths on *sarafans*. Floral forms were characteristic of golden embroidery, though geometric motifs were also used in the south of Russia. On headdresses and lined jackets, a symmetrical pattern in the form of a fantastic bush or a tree was embroidered against a colored background, the stems of the bushes containing tulips, pinks, camomiles and other flowers (see C-9). Kerchiefs of light, bright or white silk, muslin or calico embroidered in gold also had floral patterns of garlands, with roses, bunches of grapes and many-petaled flowers predominating. The basic pattern was decorated with light curls, tendrils, spangles and different meshes which softened the transfer from the background to a raised ornament made on "flooring" or without it. The spun metallic threads were supplemented by the so-called *bit*, a narrow glittering metallic flat thread. The *bit* increased the decorative expressiveness of the pattern, emphasized the lightness and weightlessness of silk in the thinned pattern or the magnificence of a completely filled in corner of a kerchief (see Figures 4-35, 4-36).

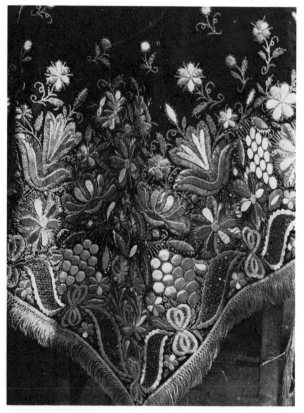

4–35. A taffeta kerchief with gold embroidery. Nizhegorodsk province, the 19th century. (Museum of Folk Art. Photograph by N. T. Klimova.)

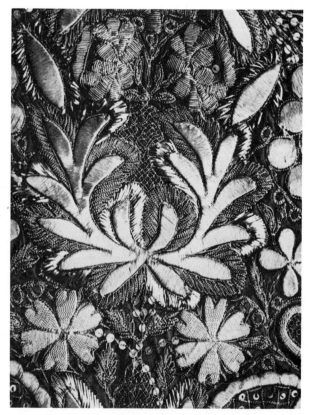

4–36. A detail of the kerchief. Nizhegorodsk province, the 19th century. (Museum of Folk Art. Photograph by N. T. Klimova.)

Russian embroiderers were not all masters of golden embroidery. This technique of embroidery was always handed down from mother to daughter; it was taught at workshops of local cloisters. Embroiderers skilled in golden embroidery were famous far and wide and were given orders not only by people from their own village but by inhabitants of other areas as well. In the 19th century there were several regions that specialized in making golden embroidery for the trade. They were situated in the Nizhnegorodsk, Archangelsk, Olonetsk, Novgorod and Kostroma provinces. However, the town of Torzhok was the most famous. In this town complete headdresses were embroidered for many provinces of Russia. Besides headdresses, the embroidery was used for adorning muslin sleeves, aprons, kerchiefs and long transparent covers. In the town of Torzhok golden embroidery was done both on light cloth and on thick velvet and silk; that is why merchants and prosperous peasants of different provinces of Russia gave the embroiderers of Torzhok numerous orders for making wedding cos-

tumes for brides. Golden and silver threads were also used for embroidering Morocco footwear, belts, purses and other hand-made goods of leather and chamois; these were designed mostly for the town consumer. Torzhok embroiderers more than once embroidered the attire for the tzar, especially during the reign of Catherina the Second and Alexander the Third. In the gold embroidery ornaments made by Torzhok embroiderers two kinds of ornaments were developed at the same time. On some headdresses they used geometric motifs. On kerchiefs they basically used floral forms with a generalized interpretation of flowers and leaves according to ancient Russian traditions. For the ornament of those articles that were designed for the town consumer, magnificent roses surrounded with clusters were predominant. Besides spun metallic threads embroiderers used the so-called *bit*, spangles, *strunzal* (a metallic spring) and foil which created a constant alternation of lights and darks and enriched coloring in the pattern. For examples of the stitches used, see Figure 4-37.

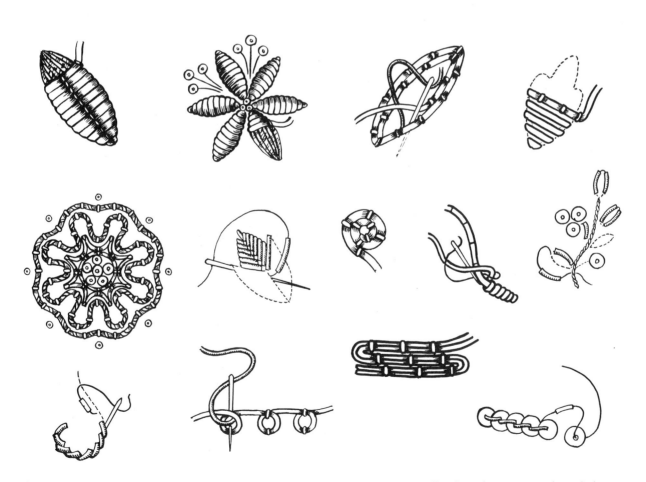

4–37. Examples of stitches found in gold embroidery using metallic threads, ropes and cords.

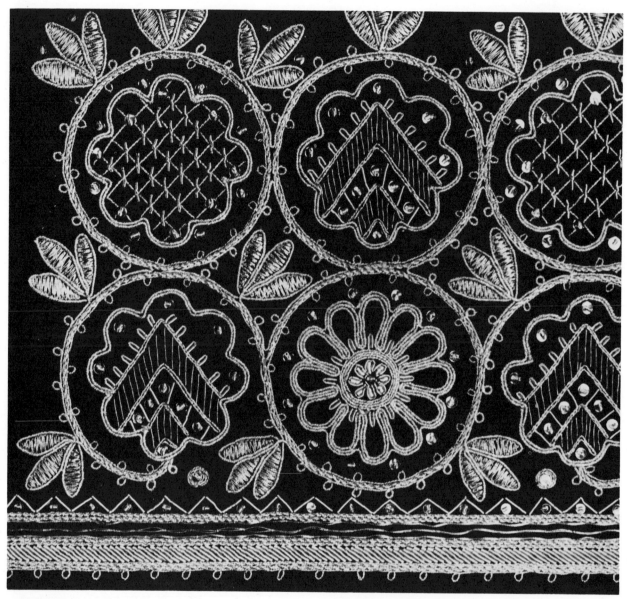

4-38. A blotting pad (detail), made of chamois with gold embroidery. (Made by L. S. Filonova. The Storehouse of the Scientific Research Industrial Arts Institute. Photograph by V. M. Obukhova.)

Chapter 5

Embroidery of the Volga and Ural Regions

The art of adorning cloth has always been very popular among the peoples of the Volga and Urals: the Mordvinians, the Mari and the Udmurts, who are representatives of the Ugro-Finnish languages; the Bashkirs and the Chuvashs, who belong to a Turcic languages group; and the Kazan Tatars who live near the middle Volga. The culture and art of the multinational population of the Volga and Urals were formed through the course of several centuries; the process of a complex interlacement and interpenetration of the mode of life of these peoples was favored by the nearness of their territories, similar conditions of their life, and similarity of their histories and economic structures. This similarity was displayed in their clothing and their ways of decorating cloth. A white linen shirt in the form of a tunic and decorated with bright overstitch embroidery was the basic costume of all the peoples of the Volga and Urals (Figures 5-1, 5-2). Textured counted stitches in silk or wool were predominant. Embroiderers of the Volga and Urals also embroidered household linen, paying special attention to articles designed for ceremonies, for example, weddings, funerals and different folk holidays. A Bashkir *sabantui* serves as an example: according to a Bashkir tradition, the winner of a wrestling match, a horse race or other traditional competitions is rewarded with an embroidered kerchief or towel, which is especially prepared for this purpose by recently-married young women.

The popularity of embroidery is explained by ancient traditions: each woman had to know how to sew and embroider. That is why a Bashkir girl was taught to embroider at the age of five or six. By the time of her marriage, a Bashkir girl had to have a complete trousseau. The girl spent many days preparing her trousseau, which served as a criterion of her mastery, taste and industry. In this difficult work, the daughter was helped by the mother or grandmother, and sometimes by the most skilfull embroiderer among her relatives. They taught the girl all the secrets of the complicated art of embroidery.

The basic parts of the trousseau of the peoples of the Volga and Urals were similar: holiday and ritual towels, tablecloths, pillowcases and other household linen. And yet some differences existed. For example, according to Bashkir traditions, a bride brought brightly embroidered *chepraks* to her bridegroom's house, while the Chuvash bride brought kerchiefs. The basic parts of the trousseau of all the peoples of the Volga and Urals include headgear, kerchiefs, covers for the bride, belts, caftans, and, especially, holiday and everyday shirts, the number of which often reached one hundred (Figures 5-3, 5-4, 5-5). The shirts of the peoples of this group were usually decorated around the hem, the sleeves and a low neck (Figure 5-1). Articles for the trousseau and those designed for a wedding ceremony were decorated with embroidery or a figured spinning.

Despite the abundance of common features,

the national embroidery of each group was individual. Styles were formed in the process of creating articles for everyday life, but with due regard for local traditions. The Mordvinians, the Maris and the Chuvashs primarily used counted stitches that resulted in ornaments of a geometric character. The Tatars, the Bashkirs and the Udmurts used the *tambour* embroideries, preferring light and multicolored ornaments to counted stitches.

According to the Mordvinian, Mari and Chuvash tradition, richly colored embroideries on linen were made primarily with oblique stitches, counted satin stitches, "painting" or *nabor*. The characteristic feature of the national embroideries of these regions is their carpet-like appearance, as well as the refinement of colors used, often based on the combination of two colors, though bright and multicolored embroideries are seen as well.

Embroideries were mainly done with woolen or silk threads, both being used in one pattern. The threads were dyed at home with vegetable dyes which imparted a soft and deep tone to the fluffy wool and glittering silk. Bright red, red-brown, blue and black tones were considered to be basic colors in these regions.

Despite the similarity of embroideries done in counted stitches, each national group had its inherent features. Along with the stitches mentioned above, the Mordvinian embroiderers used raised stars and spiral stitches. They created an incomparable "bulging" texture in the pattern and a very rich play of lights and darks in the ornament (Figure 5-5). The colors used in the Mordvinian embroideries is also unusual: a combination of dark red and dark blue (almost black). To emphasize the decorative expressiveness of the ornament, embroiderers inserted yellows and greens and often added spangles, glass, beads, or small plates.

The geometric motifs of Mordvinian embroidery are simple in their configuration. They consist of lozenges, stars, squares, circles and points. However, in some districts, the pattern also included geometrical floral motifs which formed branches with flowers, rosettes and long feathered leaves.

The Chuvash counted stitch embroideries differ markedly from the Mordvinian ones in color, texture and composition. They are characterized by the combination of three to five counted stitches. In addition to the most popular stitches (oblique stitch, counted satin stitch and "painting") the Chuvash embroiderers used up to fifteen other

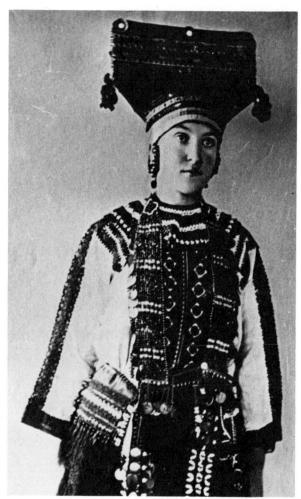

5-1. A Mordvinian woman in the national holiday costume. The linen shirt is embroidered with woolen threads. (From a set of 1915 postcards: Ancient Women's Costume of Different Regions of Russia. Photograph by N. T. Klimova.)

stitches, for example: a cross, a "wisdom" stitch, a trivial stitch, a rope and so on. Modifying them, the Chuvash embroiderers created light patterns which were only slightly raised above the background and dense raised patterns, the combination of which resulted in a texture specific only to this group. The linen towel headdress called a *suran* is an example of such embroidery; it is characterized by a multitiered composition consisting of smooth and figured strips. These *surpans* had a delicate coloring in which dark red, light blue, green and golden tones prevailed (Figure 5-6).

The embroidery of Chuvash women's shirts, especially the *keske* (Figure 5-7), merits special attention. The embroidery usually consisted of two to four rosettes-stars which were situated on both sides of a low cut front. According to ancient

beliefs, a *keske* was a symbol of the life-giving Sun, the basis of life on Earth. The motifs were to protect the breast of a woman from illness and the "evil eye." The form of a Chuvash *keske* had many variations. However, each rosette-star was based on a small lozenge or a square with different sprouts and branches, turning the original form into a bright golden and red flower with fantastic petals.

In speaking about the Chuvash embroidery we should pay special attention to the famous kerchiefs worn by bridegrooms—*sulach* and *keru tutri*. The embroidery of these kerchiefs formed a broad edging inside of which large squares or rectangles were embroidered in the corners. Sometimes the embroidery covered the whole background of the kerchief so that only a small white square was left in its middle. On the *keru tutri*, a rectangular kerchief, the composition consisted of large alternating linear motifs into which embroiderers inserted beautiful rosettes-flowers or geometrical birds standing in pairs near a tree (C-11).

In their embroideries, the Mari preferred to use dark-red oblique stitches or counted satin stitches with dark-blue, almost black contours. Yellow and green colors were inserted into the main tone of the embroidery. The pattern was always dense with clear spaces in the background. The Mari embroideries were of the "carpet" type, in which the background and the pattern were densely covered with short stitches of colored threads. The ornament motifs clearly stood out against a wide contour outlining each form. The embroidery was usually done with a counted stitch or oblique stitches.

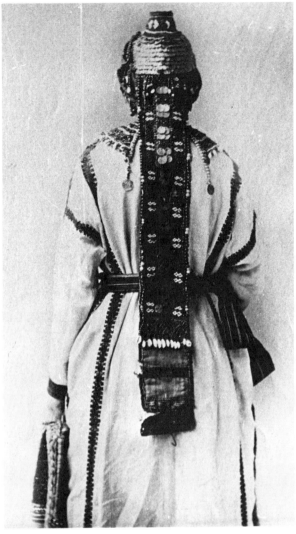

5–2. A Mordvinian woman in the national holiday costume. (From a set of postcards: Ancient Women's Costume of Different Peoples of Russia. *Photograph by N. T. Klimova.)*

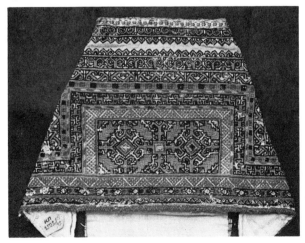

5–3. A 19th century folk headdress made of linen and embroidered with oblique stitch, counted satin stitch and "painting." (Museum of Folk Art. Photograph by N. T. Klimova.)

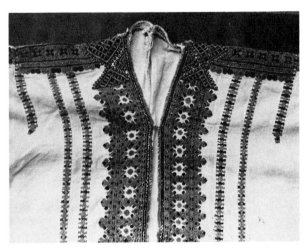

5–4. The upper part of the 19th century Mordvinian women's shirt. Made of linen and embroidered with colored wool threads: the Mordvinian star, counted satin stitch, "painting," oblique stitch along the spiral, and braid. (Museum of Folk Art. Photograph by N. T. Klimova.)

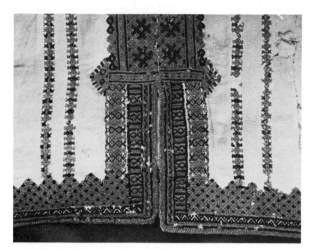

5–5. *The lower part of the shirt in Figure 5–4.*

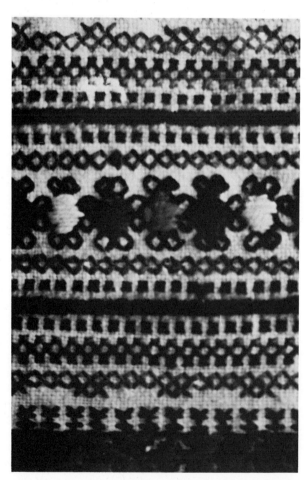

5–6. *A detail of the Chuvash headtowel (surpan). Made of linen with "painting," counted satin stitch, cross stitch and braid stitch. The 19th century. (Museum of Folk Art. Photograph by N. T. Klimova.)*

The Mari worked out their own range of motifs, combining the features of a strictly linear geometric ornament and elements of tendrils and hooks which were considered to be a symbol of richness and prosperity in a cattle-breeding culture. That is why the Mari lozenges and other geometric figures had double rounded sprouts in different configurations; they were accompanied by ornamental stripes with hooks. Taken together these motifs formed a complex composition of narrow and wide stripes. This range of motifs in Mari embroidery was enriched by floral forms and pictures of birds, horses and tortoises. Among the floral motifs of the Mari, one can most often see branches with large, open flowers or with unopened buds.

In the Udmurt and Bashkir embroideries of the 18th and 19th centuries *tambour* embroidery was very popular. Counted stitches—oblique stitches, two-sided satin stitch and "painting"—were also of the greatest importance. Besides woolen and silk threads, the Udmurts often used metallic threads. In connection with this, tradition dictated that the relatives of a bridegroom present his future bride with a skein of silver threads which she was to use for her trousseau.

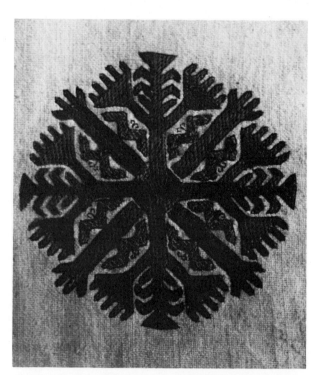

5–7. *Keske, a symbol that appears on the front of a woman's Chuvash shirt. Made on linen with oblique stitch and "painting." The 19th century. (Museum of Folk Art. Photograph by N. T. Klimova.)*

The Bashkir oblique stitch embroideries were characterized by special beauty and elegance. They were used on ancient *harauses* (the forehead part of a splendid national headdress called *kashmad*), which were abundantly decorated with coral and shells.

The most beautiful parts of the Udmurt women's clothing were headdresses and bibs called *kabach* (Figure 5-8). They were embroidered primarily with counted satin stitch and oblique stitches. Their patterns were extremely diverse. Each pattern had a definite meaning in a holiday costume. For example, a bib with eight pointed stars, called *lunar*, was considered to be a wedding bib. Bibs with a large figure in the form of a cross was worn only during prayer in a sacred grove. A bib with a large stepped pyramid was worn when visiting or during "holiday walking." However, despite the definite meaning of basic ornamental motifs, the embroidery of the Udmurt

bibs was characterized by individual features. The composition of the pattern, the colors which changed depending on the number of green and golden insets, the placement and form of the motifs made with silver threads—all this was unique.

It is necessary to point out that the oblique stitch, counted satin stitch, "painting" and other counted stitches are flexible techniques of embroidery. They enabled the embroiderer to get patterns of different character, from dense patterns of a "carpet" type to light and elegant patterns. Each group worked out their characteristic features of the ornament, coloring and texture.

Shown are two diagrams (Figures 5-12, 5-13) for embroidering Chuvash and Mordvinian folk ornaments. They can be done with counted stitches: an oblique stitch, counted satin stitch, "painting" and *nabor*.

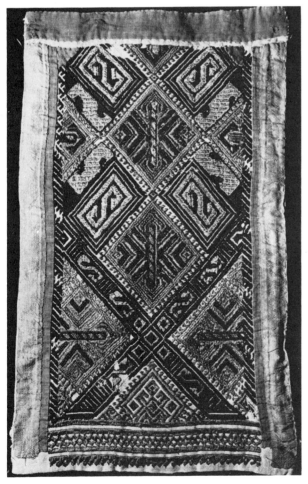

5-8. A bib for a woman's wedding costume. Udmurt (Glasov region), the middle of the 19th century. (From Krjukova: Udmurt Folk Fine Arts, Izhevsk-Leningrad, 1973, table 12. Collection of photographs of the Scientific Research Industrial Arts Institute.)

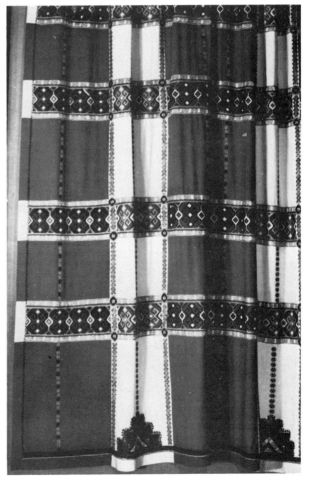

5-9. A curtain made according to the motifs of Mordvinian folk embroidery. Made of broadcloth with counted satin stitch, oblique stitch and Mordvinian star. (Made by T. A. Dunaeva. The Exhibition Fund. Photograph by V. M. Obukhova.)

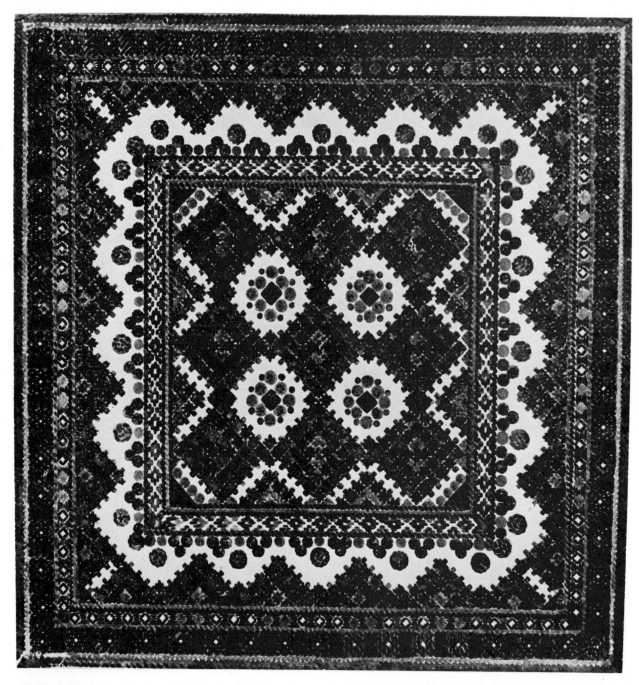

5–10. A decorative cushion made according to Mordvinian folk embroidery. Broadcloth embroidered with the Mordvinian star. (Made by L. G. Begushina. Museum of Folk Art. Collection of photographs of the Scientific Research Industrial Arts Institute.)

The Stitches

The embroidery of the peoples of the Volga and the Urals is usually worked on cloth of an even weave. Woolen, silk or cotton threads of rich red-brown color are used. They are supplemented with dark-blue or black threads. Light tones of yellow and green in small quantities can also be used.

Counted Satin Stitch. The counted satin stitch of the peoples of the Volga and Urals has always been two-sided. The stitches of the counted satin stitch are densely laid near each other. The flooring of the stitches form an even surface, either in the form of bricks having ledges or in the form of a fir tree (Figures 5-3, 5-6).

Nabor. Besides the counted satin stitch, the embroiderers of the Volga and Urals used the so-called *nabor* with which they filled compli-cated geometric patterns. For the technique of working this stitch, see Figures 2-14 and 2-16.

Oblique Stitch. The oblique stitch is the main stitch of Volga and Ural embroidery. These oblique, densely-fitted stitches result in a beautiful, slightly bulging surface which glitters when light falls on it from certain angles (Figures 5-11, 5-14).

To work oblique stitches great attention and exact counting of fibers of the cloth are needed. To facilitate the task a diagram should be drawn on graph paper. Consideration should be taken of the fact that the denseness of the warp and the weft threads may not be similar and the fibers of the cloth should be counted in such a way that the size of the stitch corresponds to the graph. The oblique stitch is done diagonally on two squares. The threadwork is shown in Figure 5-15A and B.

The spiral oblique stitch has been always used

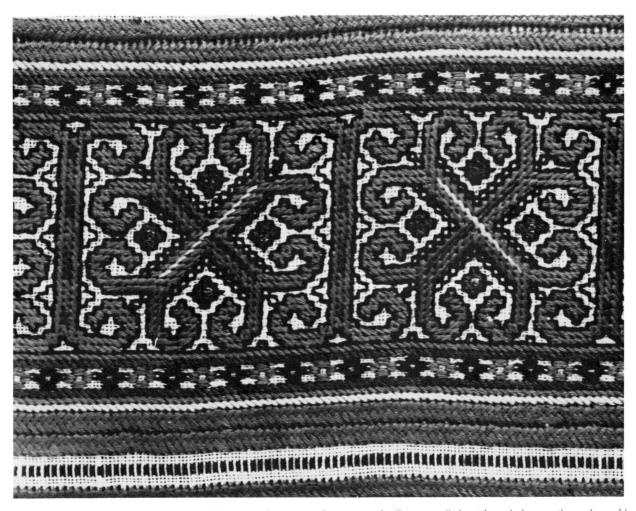

5–11. The combination of stitches (oblique stitch, counted satin stitch, "painting", braid and drawn-thread work) in a modern embroidery. (Photograph by V. M. Obukhova.)

by Mordvinian embroiderers for embroidering with thick colorful threads (Figure 5-17). The stitches are done in a spiral taking into account the number of fibers of the cloth. The threadwork is shown in Figure 5-15C, D and E. Once again, it is easier to work the pattern out on graph paper before embroidering. Embroidery done with spiral oblique stitches results in a raised bulging texture, in which each polygon is clear-cut. Sometimes in such a polygon the core is also embroidered, as shown in Figure 5-15F.

Half-Cross Stitch. The half-cross stitch was very popular in the embroidery of the peoples of the Volga and the Urals. It was often done along the contours of motifs, imparting a decorative expressiveness to the outlines of each colorful form or creating a light, airy, black pattern which accompanied the basic ornament of the embroidery (Figures 5-3, 5-6).

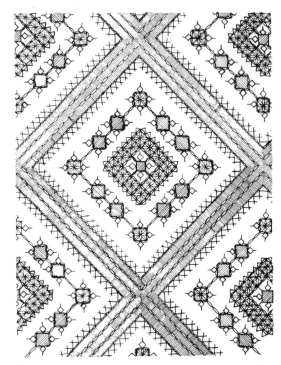

5–13. A design for Chuvash folk embroidery. The background is white, the pattern is of a red-claret color, the outline is dark-brown. The following stitches are used: oblique stitch, "painting," counted satin stitch and star.

5–12. A design for Mari folk embroidery. The outline is made with black or brown "painting," each form filled with oblique stitches of a dark claret color; the dividing stripes are of the same color. The oblique stitch or braid can be used.

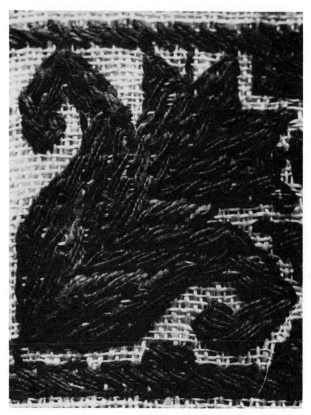

5–14. The oblique stitch. (Photograph by N. T. Klimova.)

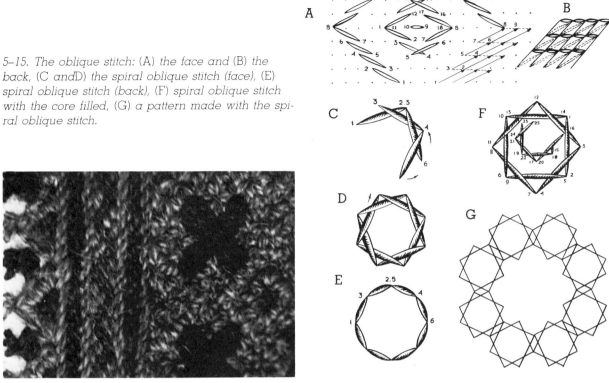

5-15. The oblique stitch: (A) the face and (B) the back, (C and D) the spiral oblique stitch (face), (E) spiral oblique stitch (back), (F) spiral oblique stitch with the core filled, (G) a pattern made with the spiral oblique stitch.

5-16. A combination of the oblique stitch, the spiral oblique stitch, the Mordvinian star and "painting" in the embroideries of women's Mordvinian shirts of the 19th century. (Museum of Folk Art. Photograph by N. T. Klimova.)

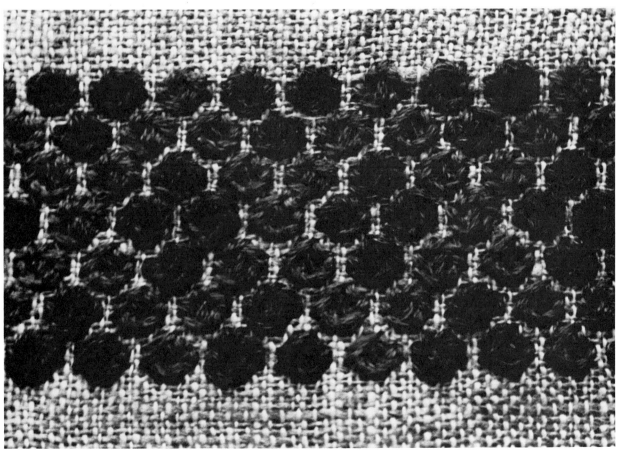

5-17. The spiral oblique stitch. (Photograph by N. T. Klimova.)

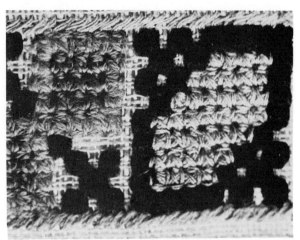

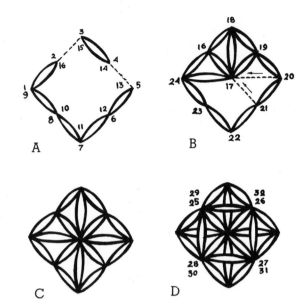

5–18. The Mordvinian star stitch. (Photograph by
N. T. Klimova.)

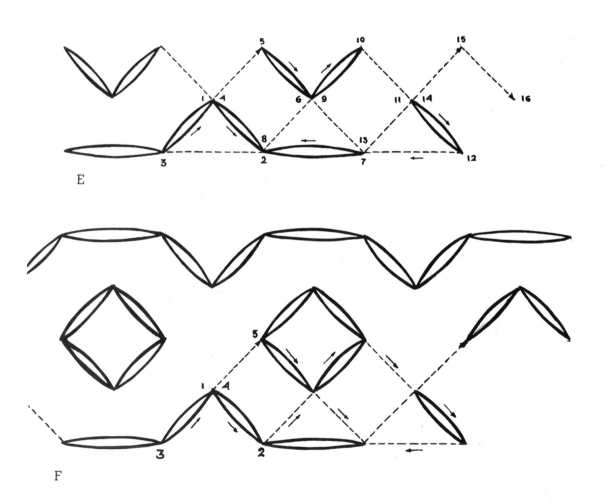

5–19. (A to D) The Mordvinian star, (E and F) the "wisdom" stitch.

"Wisdom" Stitch. The Chuvashs, the Mordvinians, the Udmurts and the Bashkirs used their own threadwork for simple motifs (see Figures 5-19E and F, and 5-20C). The horizontal stitches alternate between the face and the back of the cloth. If the size of stitches equals three cloth fibers, the horizontal stitches are done on six fibers of the warp and the weft. If the cloth is dense or fleecy, the "wisdom" stitch is done using the pricking technique. If the stitch is worked correctly, the picture on the back is exactly the same as on the face.

Mordvinian Star. This stitch is a variety of the "painting" stitch and is also one of the basic stitches in Mordvinian embroidery. The Chuvash and the Mari embroiderers also used the star but not as often. These stars were embroidered on holiday and wedding shirts, sleeves, around a low neck and on hems (Figure 5-16). The Mordvinian star also creates a bulging texture in the embroidery but it is more raised than the spiral oblique stitches (Figure 5-18). In making the star the stitches are laid along a circle. The threadwork is shown in Figure 5-19A, B, C and D.

Tambour. The most popular free form stitch, the *tambour*, has always been traditional in the national embroidery of the Tatars and Bashkirs. Among the Chuvashs, the Maris and the Mordvinians the *tambour* became popular in the second half of the 19th century, displacing counted stitches. *Tambour* was used for embroidering women's dresses of bright factory-made cloth, kerchiefs and covers, bibs, tobacco pouches and other articles. This kind of embroidery is characterized by patterns of floral character consisting of bright large leaves and flowers in the form of garlands or separate bunches. In general, these motifs are repeated but their details and colors differ. This introduces movement into a static pattern. In the Tatar embroideries the motifs of flowers and leaves are supplemented by curls or other rounded geometric forms.

Tambour was done in two ways: with a needle or with a hook. Large loops were done with thin threads which resulted in stitches raised above the background producing the impression of slightly outlined lines. Such stitches were called a "low *tambour*." Small loops were done with thick threads which resulted in raised stitches which seemed to be a cord fastened to the background. This kind of stitch was called a "high *tambour*." High and low stitches were done with a needle.

A

B

C

5–20. (A) *The double stem stitch,* (B) *the loop or edge stitch,* (C) *the "wisdom" stitch. (Photograph by N. T. Klimova.)*

With the second half of the 19th century the folk embroiderers began to use a hook. The technique of working *tambour* with a needle and a hook is shown in Figures 4-7 and 5-24A and B.

The double *tambour* consists of double loops forming a wide raised line, as shown in Figure 5-24C. The working thread runs in zigzag fashion from one edge of a raised band to the other, simultaneously taking and fastening to the cloth the loop previously formed and the loop which has just been formed. The background is slightly seen through the threads which makes the embroidered surface more delicate.

A variety of the Bashkir *tambour* is the *kuskar* technique. According to this technique the ornament is done on a paper stencil which is placed on silk or velvet in accordance with the desired composition and bordered along its contour with the *tambour* stitch or oblique stitches. In the *kuskar* embroidery the range of motifs was quite distinctive. Its main elements were figures in the form of pairs of ram's horns, spirals, simple or vortex rosettes, cross-shaped figures with rounded ends in different combinations (Figure 5-21). Combinations of basic elements of the *kuskar* embroidery result in either simple or complex ornamental compositions, including not only geometric but floral forms. This kind of embroi-

dery is multicolored and built on the contrasts of different shades of red, yellow and green. Blue and dark blue are also used, but not as often.

Besides *tambour*, appliqué and golden thread embroidery were very popular among the Tatars and the Bashkirs. Women's headdresses, shoes and tobacco-pouches were embroidered with glittering golden patterns. Metallic threads were fastened to velvet, which was primarily of green color. As with *tambour*, the pattern consisted of floral motifs in which rounded many-petaled flower rosettes and tulips of different forms predominated.

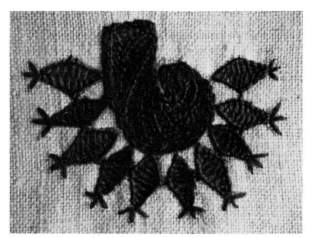

5-21. *The oblique mesh stitch. (Photograph by N. T. Klimova.)*

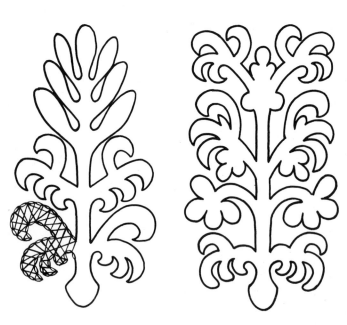

5-22. *A design for the Bashkirian kuskar technique. The appliqué is made out of bright cloth fastened to the background with colored threads, small parts of which have one branch or one flower.*

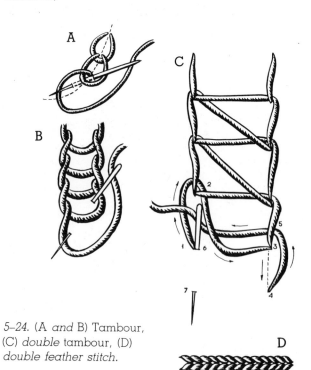

5-24. (A and B) Tambour, (C) *double* tambour, (D) *double feather stitch.*

Feather Stitch. This was used in folk embroideries for light delicate multicolored floral patterns. The embroiderers often use a feather stitch with two roads instead of one; these closely fit each other as shown in Figure 5-24D.

It should be emphasized that the folk embroiderers of the peoples of the Volga and the Urals, in their technique, the range of motifs and composition, are closely connected with the embroideries of the East (especially with the *tambour* of middle Asia). However, original features in the national embroideries of the Chuvashs, the Mordvinians, the Maris, the Udmurts, the Bashkirs and the Tatars are vividly seen in the composition of the pattern, the range of motifs and coloring.

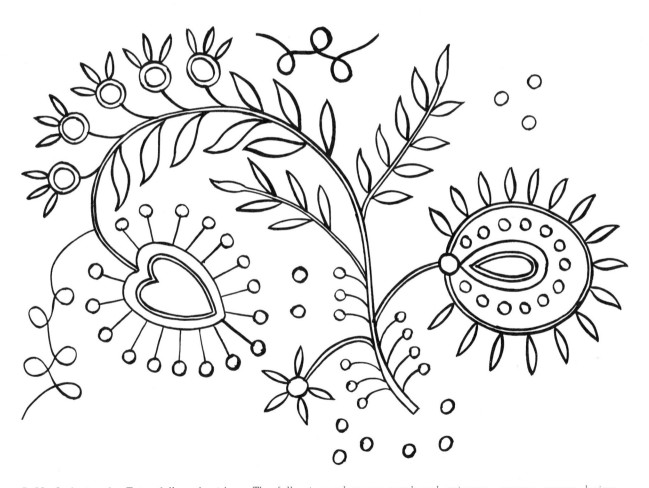

5–23. A design for Tatar folk embroidery. The following colors are used: red, crimson, orange, green, beige and blue.

Chapter 6

Embroidery of Ukraine and Belorussia

Ukrainian and Belorussian embroideries were developed as a means of decorating clothing and household linen which was handwoven. During holidays embroidered and spun patterns decorated covers and curtains, pillow cases and *rushnyky* (ritual cloths) (C-12) found in every household. The brightly patterned *rushnyky* were used for decorating windows, doors, icons, and holiday tables; they were worn by friends of the bridegroom during wedding ceremonies and were presented to guests of honor as gifts. However, the embroiderers of Ukraine and Belorussia paid much greater attention to the decoration of women's and men's holiday clothing and, primarily, to the decoration of linen shirts. The embroidery on the sleeves of women's linen shirts was the richest (C-13). The embroiderers decorated them with a variety of stitches which subtly emphasized the character of the pattern and revealed the decorative possibilities of its texture. A beautiful woman's shirt in a folk costume harmonized with patterns made on a skirt, a sleeveless jacket and headdress in which embroidery was often combined with weaving, ribbons, tapes, bright factory-made cloths and other materials. The location of a decoration and the character of a pattern as well as its color depended upon local traditions and the style of the garment.

Separate provinces, regions and even villages had their own specific type of folk costume which was a real work of art. In the Karpat areas the garments of Ukrainian mountaineers, the Huzuls, is of special interest. It is characterized by the diversity of embroideries in which different shades of red supplemented by gold and green colors prevailed. The embroiderers of some Ukrainain areas used multicolored embroideries with geometric ornaments for decorating shirts. Plain and figured stripes reddened snow-white shirts and aprons of the Belorussian woman's holiday costume. They created a complex, multitier, colorful composition. The beautiful folk costumes were worn on Sundays, when going to fairs and on holidays.

Through the course of centuries the embroiderers in Ukraine and Belorussia worked out their own techniques of embroidery, range of motifs and colors. Ukrainian and Belorussian ornaments are divided into geometric and floral, which often include depictions of birds, animals and people.

The geometric ornament made with counted stitches consists of straight and broken lines. The main motifs are lozenges of different configurations, rosettes and crosses. They are supplemented by triangles, rectangles, zigzag and straight lines. Each simple geometric form evolved to include appendages and sprouts of.

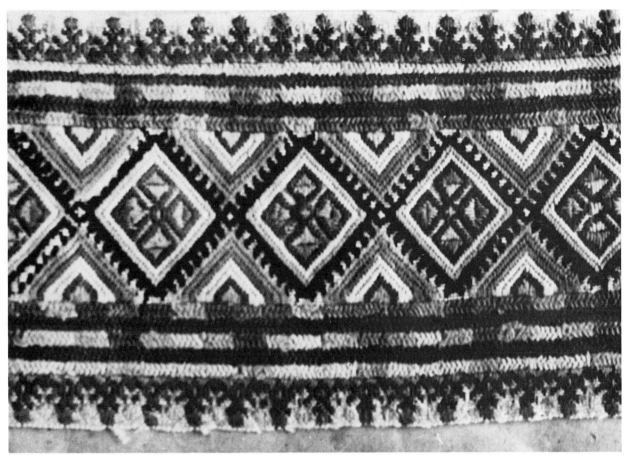

6–1. Embroidery for a woman's shirt (detail). Geometrical ornament on linen with nyz and braid embroidery. (Museum of Folk Art. Photograph by N. T. Klimova.)

different forms, mostly angular. Many motifs are named figuratively: "sheep horns," "windmill," "ox eye" and others (Figures 6-1, 6-2). Each composition has a great number of variants depending upon the combination of their forms and general selection of the pattern colors.

Embroideries with floral patterns having different interpretations of motifs were also very popular in Ukraine and Belorussia. In some regions the prevailing ornament had largely geometric patterns in the form of four-petal flowers, berries, buds and small leaves connected to each other by wavy stems. Such embroideries were most often done with counted stitches.

In other regions the embroiderers used splendid floral patterns, with roses, poppies, pinks and bunches of grapes as basic motifs (Figure 6-3). In still other regions the favorite ornaments con-

sisted of fantastic flowers and leaves in which whimsical multipetal flowers were combined with elongated leaves of unusual forms, comprising incredibly beautiful, snow-white, bright-red and multicolored patterns (Figure 6-4). Among them the following embroideries were especially popular: famous Ukrainian satin-stitched embroideries of the 18th century worked with colored silks as well as with golden and silver threads, and the red embroideries of the *rushnyky* on which counted stitches are combined with free decorative stitches, creating a texture of unique beauty. Ukrainain and Belorussian folk motifs include cocks, hens, pigeons, butterflies and other motifs which are considered to be the symbols of happiness and the prosperity of the family.

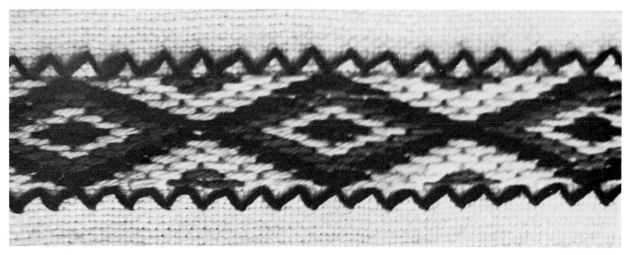

6–2. Nabyruvania, a short stitch resembling glass beads. Cherkass and Chernihiv provinces of Ukraine. (Photograph by N. T. Klimova.)

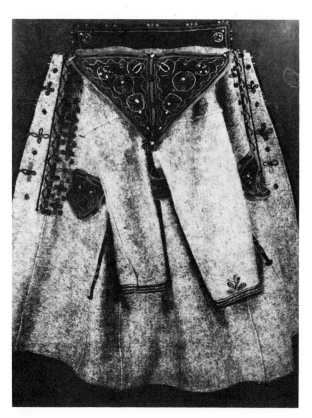

6–3. A man's wedding outfit. Kosovo region, Ivan-Franko province. (From State Art of Ethnography and Industrial Art of the Academy Sciences of the Belorussian SSR, Kiev, 1976, table 40. Photograph by V. M. Obukhova.)

6–4. Satin stitch. Kiev province. (Photograph by N. T. Klimova.)

Motifs of geometric and floral character of Ukrainian and Belorussian folk embroidery were varied by stitches used. The Ukrainian and Belorussian embroiderers used more than fifty of them. The counted stitches, closely connected with the texture of the cloth, and free stitches, which were laid freely on the cloth without counting the fibers of the warp and the weft, were extremely popular.

Counted Overstitches

In Ukraine and Belorussia counted overstitches were done with white and colored threads. The basic and most popular stitches in Ukraine were as follows: *nyz*, threading, *nabyruvania*, *nastyluvania*, *shtapovka* and cross stitch.

Nyz. This is an ancient Ukrainian stitch. The embroideries in this technique were very popular in Podol, Vinnizia and Stanislav. This stitch was used for embroidering bed covers, cloths, towels and smart clothing. The pattern was of geometrical character, having clear-cut rectilinear forms of motifs (Figure 6-1). The main forms of the ornament were lozenges, triangles and squares with different outlines. Earlier embroideries were done with red and black woolen threads; in Podol red was supplemented by blue. The pattern on the article had the form of a wide or a narrow band and sometimes a separate motif with a large background area. At the beginning of the 20th century embroiderers began to prefer multicolored patterns without clear spaces in the background. In such embroideries red predominated, as before, and it was supplemented by bright blue, light-green, pink and golden tones. Black emphasized each form, increasing the clearness and decorative expressiveness of the ornament.

Nyz is done with a weaving stitch, short stitches being laid in parallel lines close to each other and filling each ornamental form along the warp (Figure 6-8A). Folk embroiderers did a *nyz* in three ways. In the first two, the working thread goes across the pattern, densely laying parallel vertical stitches along the warp (Figure 6-8). But in some regions the embroidery is done from the back, the working thread goes from left to right. The embroidery made in this way is called a "cross *nyz*."

"Threading." This stitch simulates a shuttle weaving (Figure 6-8B). Each form of the ornament is densely filled with parallel stitches going horizontally, along the weft. This kind of embroidery is very popular in Volyn. The pattern was usually one-colored or two-colored and was often com-

6–5. Design for Ukrainian folk embroidery using rushnyk *stitches. Red supplemented by dark blue is used in the centers of flowers and on the crests of birds.*

bined with other stitches, creating a beautiful texture of embroidery. This kind of embroidery is also done with a weaving stitch from left to right and from right to left. The difference between this kind of embroidery and *nyz* is in longer stitches and more modest color of the ornament.

Counted Satin Stiches. *Nastyluvania*, *nabyruvania*, *lyshtva*, prick, satin stitch with *kachalochka*, *sucharik*, *kryvulka*, satin stitch with ribs and nightingale eyes are all types of counted satin stitch.

Lyshtva, prick and *nastyluvania* are done with white or colored threads and have densely laid stitches. Such satin stitch can be used for embroidering patterns of a geometric or extremely abstract floral character, resulting in glittering surface of motifs (Figures 6-4, 6-9). In pricking, the stitches of a satin stitch meet each other along the warp and the weft forming feathers (Figure 6-9).

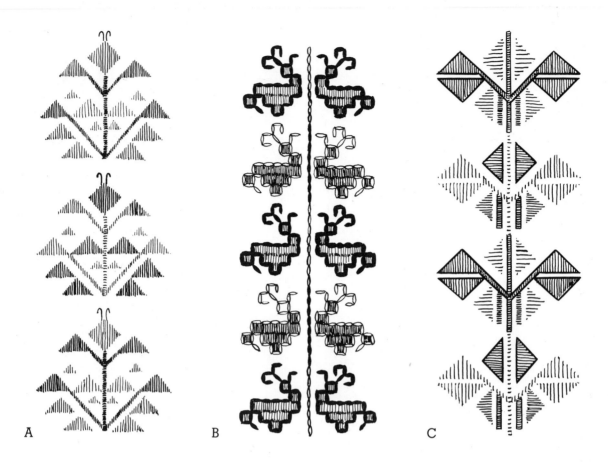

6-7. Moldavian folk embroidery: (A and C) the satin stitch worked in yellow, red and black, (B) the satin stitch with kachalochki worked in black and red.

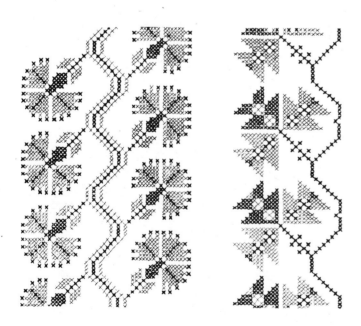

6-6. Design for Belorussian cross stitch embroidery. This is done in red and black.

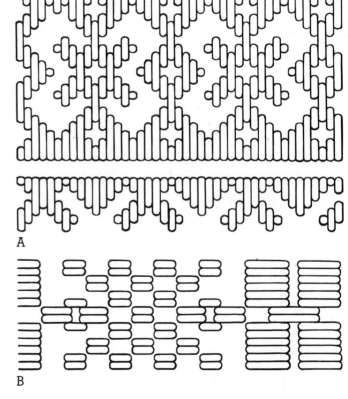

6-8. (A) nyz, (B) threading.

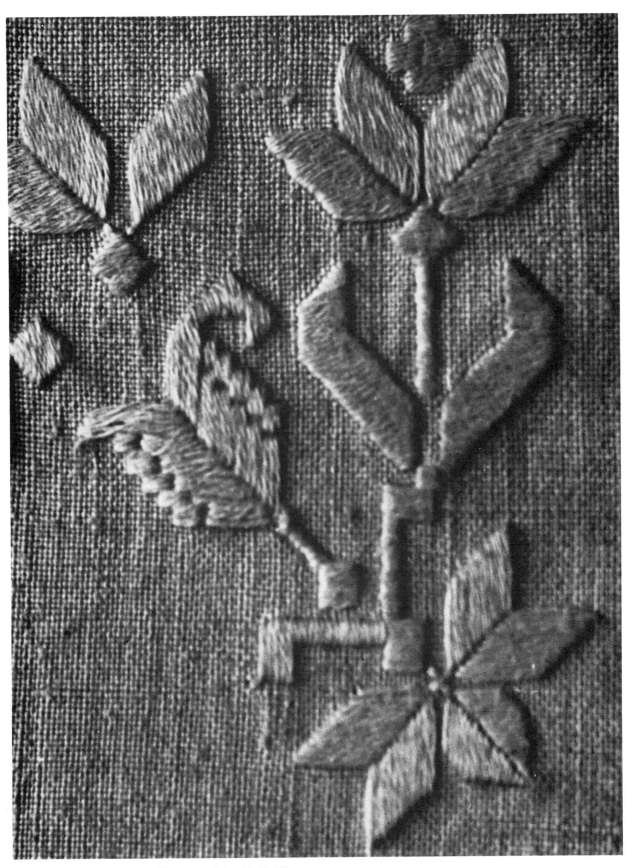

6–9. Lyshtva, *satin stitch. (Photograph by N. T. Klimova.*

Satin stitches forming an even, glittering surface of the pattern were very popular in Ukraine, namely in the Chernihiv, Poltava and Kiev regions. Ukrainian embroiderers often combined these techniques of folk embroidery with other techniques. In some cases they used a group of stars located one after another; these were called nightingale eyes (Figure 6-10A). In other cases glittering motifs of counted stitches were combined with the small openwork stitches (Figure 6-10B). White and colored embroideries were also popular. In them a counted satin stitch is combined with "painting," which is called *shtapovka* in Ukraine.

Nabyruvania is another variety of the counted satin stitch. It is done with the finest stitches of colored threads resembling glass beads (Figure 6-2). Such embroideries are characteristic of the Chrenihiv, Kiev and Cherkass regions. The ornament combines strictly geometric and geometrized floral motifs. Kiev and Chernihiv embroiderers preferred simple motifs made with white, red and black threads, sometimes supplemented by yellow threads. The background of such bright-red and snow-white embroideries was left free. The Cherkass region was famous for its multicolored dense embroideries of geometric character, whose background and pattern were filled with colored threads, red, orange, yellow, gray and black colors predominating. The stitch is done from left to right using the finest stitches densely laid near each other. The beginning of each succeeding stitch is near the middle of the preceding stitch, as shown in Figure 6-10C.

Ukrainian embroiderers liked to combine several stitches, creating a beautiful texture of a pattern having a very rich play of lights and darks. Such embroideries were usually multicolored and had only smooth counted satin stitch bands or a stitch called the "braid."

Cross Stitch. In the second half of the 19th century embroidery done with a cross stitch became widespread in the Dnipropetrovsk region, in Zakarpatia as well as in Belorussia. Red and black-red patterns were usually of a geometric character. In the Chernivitzi region the cross stitch embroideries were multicolored, with shades of red, yellow, orange, green, pink and black tones. The pattern resembled a summer meadow with small bright flowers (Figure 6-11).

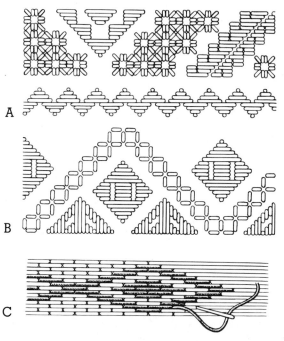

6–10. (A) *Ribs with "nightingale eyes"* (B) lyshtva, (C) nabyruvania.

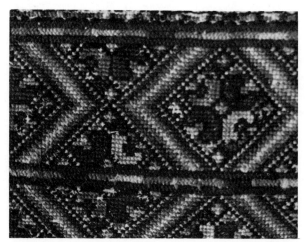

6–11. *The cross stitch. It is popular in the Dnipropetrovsk and Chernihiv provinces as well as in the Carpathian areas. (Photograph by N. T. Klimova.)*

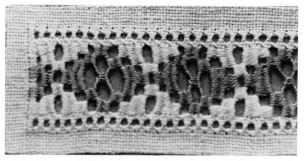

6–12. *The shabak. (Photograph by N. T. Klimova.)*

Belorussian embroiderers used mainly cross stitch. With this stitch, they created patterns full of beauty and poetry. Inimitable in its beauty, the pattern embroidered against a white background of linen was always radiant with a clean, bright red color. Some shades were sometimes added to this color resulting in a balanced harmony of all colors. The Belorussian embroiderers always tried to make the form of the ornament larger and more complicated.

Belorussian and Ukrainian embroiderers work the cross stitch in the following way. First, after counting the number of fibers, diagonal stitches inclined to one side are laid. Then, on the return of the needle across a row, the first set of diagonal stitches is covered with a second set of stitches which results in crosses (Figure 2-30).

Openwork Stitches. In Ukraine these stitches are divided into drawn-thread and cut work. The most popular drawn-thread works are called a *ljachovka* and *shabak.* In a *ljachovka* loose fibers are tightened into bundles with an airy loop (Figure 3-7). In *shabak*, columns are twined with colored threads using a darning stitch which results in multicolored dense patterns. Sometimes a darning stitch is combined with intertwining which brings additional rhythms into geometric ornaments (Figure 6-12, 3-16).

Cut work is a Ukrainian embroidery in which the twining of columns is combined with the satin-stitched embroidery (Figure 6-13). In this kind of embroidery, great cells, in which eight to ten fibers are removed and four to six fibers are left, are formed. The columns densely intertwined, the free space of cells is filled with a "flooring," darning or an airy loop.

The so-called "lazy" cut work is done without removing fibers of the cloth: cells on the cloth are filled with satin stitch using black threads, simulating clear spaces. Such open work embroideries were especially popular in the Chernihiv, Poltava and Kiev regions, where they were used for decorating clothing and household linen.

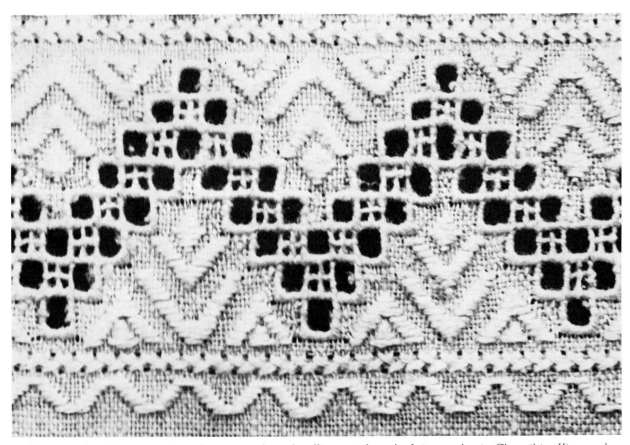

6–13. This embroidery is made with satin stitch and pulling out threads. It is popular in Chernihiv, Kiev and Poltava provinces of Ukraine. (Photograph by N. T. Klimova.)

Free Decorative Stitches

In the 18th and 19th centuries embroideries made with the free satin stitch using white and colored threads were very popular in Ukraine.

Satin Stitch. In the 18th century multicolored embroideries with silk, golden and silver threads against a light background were especially beautiful. They were made using a special kind of satin stitch in which each succeeding row of stitches was situated in such a way that the beginning of one stitch was in the middle of the nearby stitch.

These early Ukrainian embroideries strike the imagination with the poetry of a floral ornament, subtle color, unusual combinations of colored silk and glittering metallic threads. Splendid fantastic flowers make a band consisting of garlands or separate bunches. Pink, red, green, emerald, blue, dark blue, raspberry and golden tones created a beautiful range of colors. In the 19th century the Poltava embroiderers also used this stitch for making flower patterns using bright cotton and woolen threads.

White Satin Stitch. In other regions of Ukraine the satin stitch with short stitches inclined to one side was done with white threads; this created a bulging, glittering white pattern on the rough surface of light linen (Figure 6-4).

The Poltava embroiderers covered each motif of the ornament with long stitches which were then secured to the cloth with short stitches or patterned it with zigzags or lozenges.

Rushnyk Stitches. *Rushnyk* stitches were used for embroidering ritual cloths. They were very popular in Kiev, Poltava and Dnipropetrovsk regions. The composition of embroidered *rushnyk* in Ukraine was fixed: figured bands ending with large bunches of flowers or a blossoming tree at both ends of the cloth. The flowers and trees had roots or grew from a beautiful figured vase. The next part was often covered with small branches. The embroideries were usually done in red. The figured patterns were unusually complex: they either thickened against the light background of linen or turned into light strokes and points appearing on an even surface (Figure 6-14). The

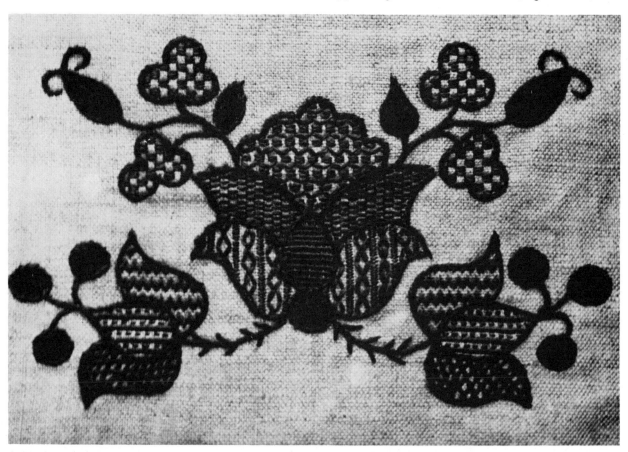

6–14. A detail of an embroidery made with rushnyk *stitches. (Photograph by N. T. Klimova.)*

folk embroiderers of Kiev often added a dark-blue color to the traditional red which diversified the range of coloring of the pattern. In *rushnyk* stitches counted and free stitches are combined. The contour of the pattern is outlined with the feather stitch or with the wide oblique satin stitch. The surface of each motif is filled with different counted stitches creating a light transparent pattern of squares, triangles, lozenges, narrow stripes, and so on. The running stitch is used, stitches of different length being inclined in one direction (Figures 6-15, 6-16, 6-17). This is supplemented by the cross stitch (Figure 6-18) or a complete filling of the motif with a Poltava stitch as well as with a counted satin stitch which create a bright, figured, raised surface.

The description of *rushnyk* stitches completes the summary of the rich Ukrainian and Belorussian folk embroidery which is characterized by a diversity of the compositions of the ornament, a wide range of motifs and unusual number of techniques of embroidery.

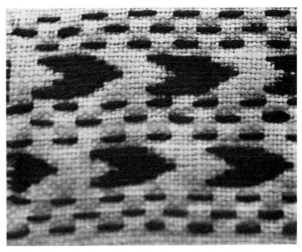

6–15. A rushnyk *stitch. (Photograph by N. T. Klimova.)*

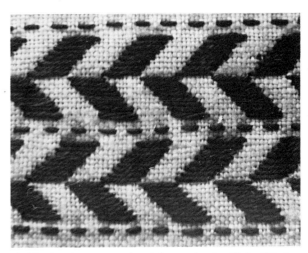

6–16. *Another example of the* rushnyk *stitch. (Photograph by N. T. Klimova.)*

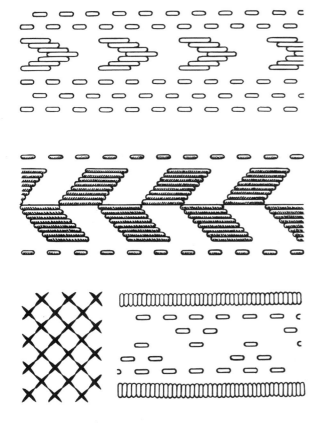

6–17. *Several types of* rushnyk *stitches.*

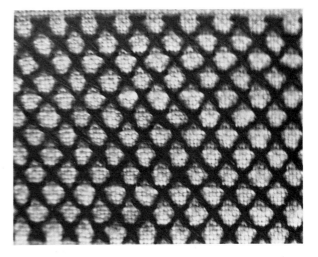

6–18. *The* rushnyk *stitch called "crest." Photo by N. T. Klimova.*

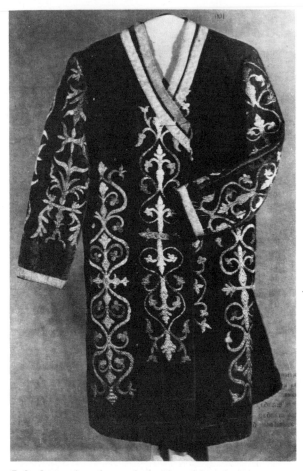

*7–2. A man's velvet robe with gold embroidery.
(From Orisbeva:* Folk Decorative Applied Arts of the
Kazakhs, *Leningrad, 1970. Photograph by V. M.
Obukhova.)*

admire the proportions and bold movement of
line in every embroidery. The artist was always
held in high respect; the techniques were handed
down from mother to daughter.

In the course of many centuries, folk embroider-
ers worked out their own ornamental system and
different principles of color selection which re-
sulted in strongly pronounced national differ-
ences in the embroideries.

One of the most ancient elements of the orna-
ments of the nomads was the sheep's horns; this
symbolized the increasing of the herd, the wealth
of the family. The horns were formed by double
curls embroidered in one line or forming a rosette
with eight curls. The second ancient element of
the ornaments was the rosette, which symbolized
the Sun and life-giving forces of Nature. Names
of the later motifs testify to the connection of
embroidery with the mode of life of the people:
almonds, dog tails, etc.

Uzbek embroiderers preferred floral ornaments
with bright, tense colors. Basic motifs included
irises, pinks, lilies, tulips, pomegranates, cotton
and almonds. Uzbek embroideries are character-
ized by clean tones and the absence of shade
changes in the coloring of separate motifs. Var-
ious shades of red, green, blue, crimson and
gold prevailed; they were often supplemented by

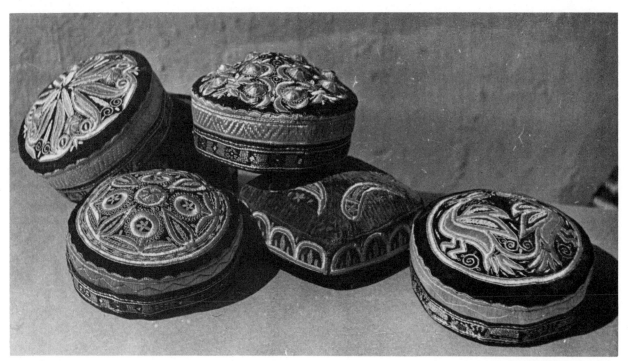

*7–3. Skullcaps embroidered with gold threads. These are produced on a mass scale by a Buchara gold em-
broidery firm, Uzbek SSR. (Photograph by N. T. Klimova.)*

black. A rich play of colors was created by reflections of light on certain parts of the pattern covered with dense rows of stitches, each motif running in its own direction.

The Kalmik ornament was characterized by the cleanness of coloring and the richness of hue of a single monochromatic scheme—from the lightest to the darkest shades of one color.

Kazakh embroideresses most often used bright red and white colors in an embroidery, but, often, their patterns were multicolored, resembling the spring flower of the steppe.

One of the outstanding features of the ornament of the nomadic peoples is the symbolism associated with color. For example, according to the Kalmyks, blue symbolized eternity, calmness and love, white symbolized unity, cleanness and innocence, black symbolized unhappiness and disaster, yellow symbolized richness and holiness, and red meant joy.

7-4. A design for a beautiful gown made according to the Kalmyk folk embroidery. The background is colored, the pattern is done with gold woven threads, thin metallic threads and spangles. This design can also be done with gold silk.

The ancient art of embroidery of Central Asia is still practiced today. The art of golden embroidery, *tambour*, appliqué and other methods of creating a pattern with the help of a needle, threads and bright cloth is developing in large towns and small villages. It is especially characteristic of the towns of Tashkent, Samarkand, Ashkhabad, Alma-Ata. The Buchara embroiderers are also famous for their skill in embroidering skullcaps (Figure 7-3).

The Stitches

The embroidery of the nomadic peoples was done on leather, broadcloth, velvet, woolen and cotton cloths. Patterns were embroidered with woolen, silk and metallic threads. Folk embroiderers used various techniques for embroidering a pattern, each being designed for a definite kind of article and definite material.

Thick Felts. The Kazakhs and Kirghizs used the technique of cutting one color into another. The technique is simple and completely corresponds to the use of the article. The makers put a piece of felt of one color on a second piece of felt of another color, outlined the intended pattern and cut both layers at once with a knife according to the outline. Then they put the ornamental motifs of the felt of one color into the gaps of the other, getting an interchangeable pattern. The joins of the two colors were sewn with short stitches. The carpet was lined, the lining being fastened to the felt with short parallel stitches. Then a cord was sewn along the seam. This cord played an important role in the general coloring of the felt carpet; depending on the range of the pattern, it could be either dark or light.

Appliqué. The technique of appliqué achieved perfection in Central Asia. For the embroidery, thin felt and different cloths were used. Wall carpets, felt covers for trunks, bags for plates and dishes as well as pillow covers were adorned in this way. Floor carpets, which were part of a trousseau, were of special value. During holidays such carpets were put on the floor at the entrance of the *jurta* as a special decoration. The background of these carpets was usually white, the appliqué pattern made of broadcloth and felt being bright and colorful. In the ornament, stylized floral curls prevailed. Forming lozenges and circles, these curls glittered against the background of a lozenge-shaped mesh (Figure 7-7). Sometimes appliqué was combined with embroidery done with silk, golden or silver threads.

The pattern was outlined on the background.

7–5. A design for decorative articles made according to the motifs of Uzbek folk embroidery. The tambour stitch is used. The boxes are red and orange, stems and leaves are gold-green, and the outline is light-green of a warm tone.

7–6. A design for decorative articles made according to the motifs of Uzbek folk embroidery. The basma stitch is used. The petals of the flowers are red, stamens are orange, leaves are green, and the outlines of leaves and curls are of ochre-brown color.

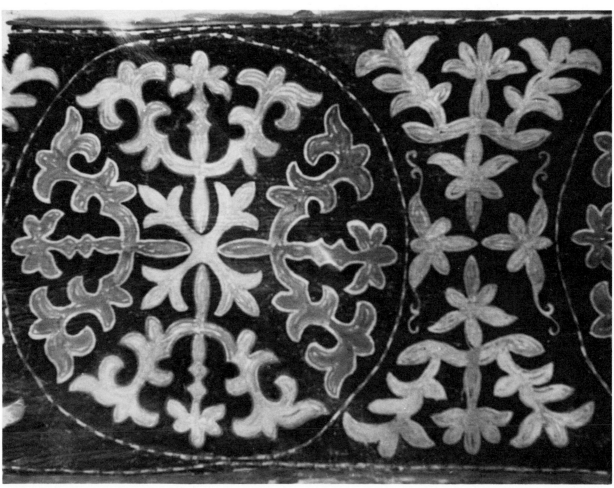

7–7. Detail of a wall carpet, tuskiiz, (detail) from central Kazakhstan. The carpet is velvet and the appliqué is worked with colored tambour. The 20th century. (Sketch by Z. Puchkova, 1968. Photograph by N. T. Klimova.)

Then different motifs were cut out of cloth, were secured with large stitches following the pattern and were densely edged with colored threads or fixed to the basic cloth with a loop-shaped cord.

***Prikrep* Satin Stitches.** Central Asian embroideries are characterized by stitches based on an entire filling of large areas of a pattern. These embroideries were made with silk and cotton threads. Uzbek, Tajik, Kirghiz and Kazakh embroiderers used satin stitches for decorating clothes and household articles. Kazakh embroiderers usually used satin stitches for decorating women's headdresses, gowns, bed curtains, towels and small household articles.

Uzbek and Tajik needlewomen were famous for their skill in creating decorative embroideries for the wall panels which were called *sjuzane*. They were noted for their great artistic sense in where to locate a pattern on the surface of the cloth: they did not overload it with unnecessary details, and, at the same time, did not leave needless empty spaces.

Uzbek and Tajik embroiderers preferred free positioning of motifs following the rhythm of floral sprouts in nature; this imparts a special vital power to the decorative embroideries. Liveliness is felt in everything, both in the outlines of every flower and in the slow run of smooth lines of stems and branches. Because of the colors used, these embroideries are always bright and festive. Against the white background one can see glittering green, red, crimson, blue and golden silks in densely embroidered rosettes of flowers and in light, lacy, green branches. Each motif is worked out in detail, both from the point of view of the pattern and of the coloring (Figure 7-8). There is also another style of the *sjuzane* pattern—a geometrical one. Such embroideries are monumental and tense in their color. Multicolored rosettes sparkle against the bright red background of the *sjuzane*. Great sense is felt in the selection of tones. Embroiderers used similar and contrasting tones; for example, cornflower blue and blue, red and light crimson, yellow and golden, violet and yellow, and so on. Each piece of Uzbek and Tajik embroidery testifies to the unusual poetic gift of the nomad women and to their high artistic taste.

The *prikrep* satin stitch embroideries were done using the following technique. On the face of the cloth, from one end of the motif to the other, the embroiderer laid in a row of a colored working thread; on the reverse trip, this row was fastened to the background with small stitches (Figures 7-8,

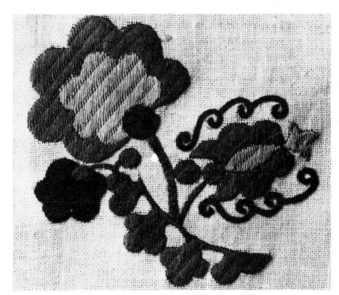

7–8. A pattern made with the basma *stitch. (Photograph by V. M. Obukhova.)*

7-9, 7-10). Such embroideries are characterized by small stitches which create a distinctive surface of the embroidered motif.

Basma is the basic satin stitch used in the embroideries (Figure 7-9A, 7-10A, 7-11). The stitch is worked toward the embroiderer. In *basma* the stitches are short and slightly inclined, relative to the long working thread. The stitches of each row are spaced relative to the previous one and they are inclined to one side. As a result, diagonal lines are formed; the surface of the embroidery resembles twill (Figure 7-8). The back of the motif is evenly filled with stitches which are a little longer than the stitches on the face. There are large *basmas* having great intervals between rows of stitches as well as a small *basmas* which approach jeweler's art in technique. This kind of stitch is characterized by a great strength and has a long life.

The *basma* stitch has a number of variations according to the location of the stitches which fasten the long working thread to the cloth; this changes the texture of the surface embroidered. Stitches may form two rows, have a checkerboard order or they can almost cover the main working thread (Figures 7-10B, C, F and 7-9F). Stitches can have different forms: some of them can be inclined relative to the thread, while others can be almost perpendicular to the "flooring." This also influences the variations of the embroidery texture.

To preserve an even surface texture, parallel lines are made on the pattern with a pencil. These lines show the location of the short stitches. Motifs made with the *basma* stitch were usually outlined with the *tambour* stitch.

At times, Uzbek embroiderers placed stitches in rows perpendicular to the basic working thread (Figure 7-10D). This stitch is used for embroidering straight lines bordering the cloth. Sometimes it is used for filling small details and motifs of the ornament. Motifs filled with this stitch are never outlined with the *tambour* stitch; it itself makes a slightly raised roll along the contour.

A two-sided satin stitch was used in Buchara, Kirghiz and Karakalpak embroideries; it is worked with a "needle forward" stitch. First, stitches are alternately done on the face and the back along the motif. Near edges, stitches may be short. In the reverse threadwork, clear spaces in the row formed are filled. In the second row stitches are done in such a way that their beginning and end are in the middle of adjacent stitches, as shown in Figure 7-10F. Embroideries worked in this way have a beautiful, glittering, silky texture.

The Cross Stitch. The cross stitch is very popular throughout Central Asia. It was used for decorating household articles and decorative carpets. In the Karakalpak province the cross stitch was used for embroidering the "white" clothing of elderly women, white saddle-girths for horses, as well as gowns for girls and young women. In Buchara the cross stitch was used for embroidering rich dressing gowns. See Figure 2-30 for the technique of the stitch.

The *Tambour* Stitch. The *tambour* is the most popular stitch among nomadic peoples of Tiurk origin. It was used both for filling large areas of the ornament and for doing small details. The *tambour* stitch was also used for outlining large motifs filled with a *basma* stitch. The *tambour* chain always runs along the contour of the motif, then is turned inward and is densely laid next to an adjacent row until the whole form, from the

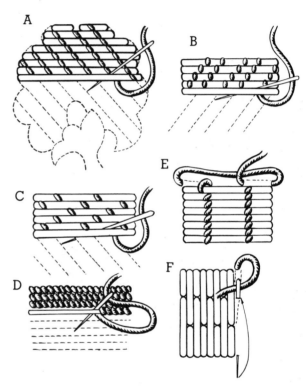

7–10. (A to E) *The* basma *stitch and its variations,* (F) *the two-sided satin stitch.*

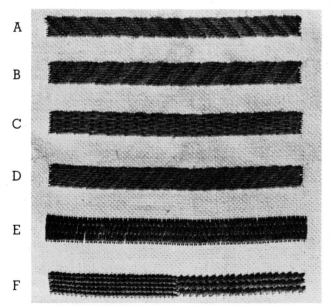

7–9. The basma *stitch and its variations. (Photograph by V. M. Obukhova.)*

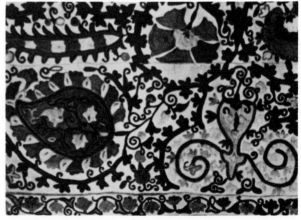

7–11. A fragment of a Uzbek sjuzane. It is made of cotton cloth and embroidered with the basma stitch. (From Decorative Art, 1957, No. 2, p. 58. Photograph by N. T. Klimova.)

edge to the middle, is filled. The embroiderers were very inventive in filling large figures with the *tambour* chain; this resulted in a brightly glittering silk texture.

Buchara *sjuzanes* were especially famous for their beauty. Buchara embroideries are characterized by a diversity of color in which blue, grey, lilac, pink and light yellow tones are harmonically combined. They are grouped around rich red, crimson and green basic motifs of the ornament. The texture of the Buchara *sjuzane* is characterized by tones of a glittering silk of one color (Figures 7-3, 7-12). The Buchara embroideries have smooth curvings of thin sprouts and a diversity of configurations of a single kind of flower. To vary the surface of large motifs, the Kirghiz embroiderers left small clear spaces on the surface of the cloth and sometimes they outlined the motifs with threads of another color.

In doing the *tambour* stitch they used a needle or a small iron hook (Figure 4-7). It should be noted that besides a small chain, a variant of the *tambour* stitch was used in Central Asia, especially in Uzbekistan and Kirghizia. In its technique this Central Asia *tambour* was an exact copy of the embroideries of the peoples of the Volga (Figure 5-24). The background was seen through threads of the stitch which imparted a special decorative effect to the surface embroidered. The Turkmen embroideries are characterized by a great density in stitches, while the Kirghiz and Turkmen embroideries are characterized by wide-spaced stitches which created the impression of airy and light patterns.

Golden Embroidery. Besides creating decorative embroideries with woolen, cotton and silk threads, the Uzbek, Kazakh and Kalmik embroiderers used golden and silver threads. This way of creating a pattern with metallic threads has always been used by the people of Mongolian and Tiurk origin. From generation to generation the embroiderers developed and enriched the art of golden embroidery. Gold and silver patterns were used for decorating men's and women's clothing, wall carpets, sofa cushions, and other household articles, as well as the holiday harnesses for horses. Uzbek women from prosperous families wore caps embroidered with golden threads, skullcaps or a forehead band. Married women wore a band with glittering embroidery during their first years of marriage when meeting guests or on holidays. The band included a bright kerchief or an oblique strip of silk about one meter long, in the middle of which a pattern was fastened with gold or silver embroidery. The beautiful pattern sparkled above the forehead of a young woman, lighting up her face with the brightness of the sun. Such a precious headdress was combined with an embroidered dressing gown as well as with shoes or boots which were also embroidered with golden or silver threads (C-15).

The most beautiful part of a man's outfit was an oriental robe which had embroidered lapels, flaps, cuffs and parts of the back. The volume of the embroidered pattern was in direct proportion to the position a man occupied in society. A velvet or a silk oriental robe could be worn only by the Emir. The most skillful embroiderers worked at his palace. They were mostly men, sometimes women. The embroiderer who could combine a glittering pattern out of metallic threads with precious stones and pearls was considered to be the best.

In the Kalmik costume golden and silver embroidery decorated a front part which was worn under a girl's national costume, a long gown of bright silk fitting at the waist. Such a costume was supplemented by a small cap which was also embroidered with golden threads and sometimes with colored glass beads. The pattern was usually of a floral character and had tulip-shaped flowers surrounded by grasses with small spangled buds (Figure 7-4). The Kazakh embroiderers used golden and silver threads for embroidering velvet street clothes (men's and women's), headdresses and shoes. The trousseau of a rich girl included costly wall carpets, *tuskiizs*, embroidered with colored and golden threads. It was thought that such a carpet not only decorated a house, but also protected the inhabitants from the "evil eye" and damage to the house.

The basic material used for embroidery included gold and silver woven threads with a silk and cotton core. These metallic threads were combined with spangles as well as with bright velvet or silk appliqué. Golden threads were laid with the help of a stencil cut out of cardboard.

The Central Asia embroiderers used mostly diagonal rows (Figure 7-2, 7-3). After the whole form was ready it was outlined with a thick lisle silk thread or a gold cord. Glittering spangles were secured to the background or to basic motifs. These spangles increased the expressiveness of a pattern, imparting it with a distinctive decorative effect. The embroidery was done on velvet, broadcloth or silk.

The Stitches

The folk embroidery of the peoples of the Caucasus was characterized not only by the richness of its motifs but also by the diversity of techniques used in the execution of patterns. The embroiderers used overstitches and through stitches. They include free and counted satin stitch, *tambour*, cross stitch, openwork, *stjags*, gold embroidery with "fastening" and *proem*, and so on.

However, the embroiderers of the Caucasus also used techniques that were very rarely used in other areas. These include the three-layer stitch which creates a beautiful multicolored texture of the pattern (Figure 8-5). A wattled stitch used in Armenia was also unique. It created a delicate lace only slightly secured to the cloth. This kind of a stitch was labor-consuming and not very popular. Today, the secret of its execution is entirely lost. It should be noted that in the course of several centuries the techniques of embroidery used in the Caucasus have not changed. As with the other peoples, the national originality of the creative work of embroiderers was manifested in the coloring, the range of motifs and the composition order of a pattern, as well as in the combination of different stitches in decorating an article.

As with the embroideries of other peoples, the counted stitches in the Caucasus go in three directions: vertical, horizontal and diagonal. The ornament is usually geometric: a lozenge, triangle, polygon, eight-pointed star, and so on.

In Azerbaijan embroideries made with the counted satin stitch, *stjags*, and openwork, the ornament was built along two axes or was mirror-reflected along the vertical. In such Azerbaijan embroideries the background and the pattern were of an equal importance. Azerbaijan embroidery of this kind was used on towels and on covers which in the olden times were used for covering women's faces in the street. The pattern was delicate and effective. The luster of the light silk on the transparent cloth was always shaded by the clear spaces of the openwork.

In Armenia the town of Inap was famous for its counted stitch embroideries. In this town refined white, through and satin stitched, two-sided patterns were made on light transparent cloth. In the town of Vun the embroiderers used the *stjag* which was called the "Vun stitch." This stitch was used for filling the motifs of the pattern with straight and oblique stitches (taking into account the number of the fibers of the cloth), three fibers in each, which resulted in small clear spaces. The embroidery was done with silk of soft tones, with red predominating. The threadwork in making the counted satin stitch, *nabor*, and cross stitch is shown in chapter 2 (Figures 2-18, 2-20 and 2-30).

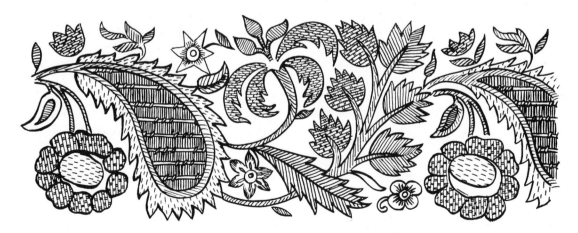

8–5. *A design for Azerbaijan folk embroidery. The two-sided satin stitch and the three-layer stitch are used. Leaves are light and dark green, the flowers are pink, orange and blue; the elongated forms have combined golden and beige tones.*

Free Satin Stitch. The technique of executing the free satin stitch was known to all the peoples of the Caucasus. It was used for making patterns of a floral character with a very lively and direct interpretation of forms. The technique of the free satin stitch facilitated the embroidery of the outlines of flowers, leaves and stems. The embroidery was done with colored silks and woolen threads. In Georgia, in the regions of Kartalina and Kachetia, a fluffy *sinel* was also used. Usually satin stitches were densely laid in parallel rows. The embroiderers of Azerbaijan and Georgia also used an arbitrary location of stitches which filled the form with light strokes, creating a complex play of clear spaces of the background. The embroidery was done with a spun thread of raw silk; for this reason the whole pattern shone and played in beams of light, which resulted in additional decorative effects.

In Georgia the atlas and "rice" stitches prevailed; in these the dense surface of the motif being filled with the colored working thread became even and glittering or resembled weavings out of thin twigs (Figure 8-6C and D). Such patterns were often supplemented by the patterns of knots and *stjags*.

In Armenia and Dagestan there was a peculiar three-layer stitch with colored silks which was also characteristic of the Arabian embroideries (Figures 8-6A, 8-7). This stitch was used for filling large surfaces of a background or large elements of the ornament. According to the planned pattern, the threads of one color or of different colors were used as seen in Figures 8-7 and C-16.

Tambour. The raised chain stitch was very popular in the embroideries of the peoples of the Caucasus. Sleeveless jackets, carpets, cushions, tablecloths, covers, bandoliers and shabracks were embroidered with colored patterns. The Azerbaijan men-embroiderers from the town of Nucha were especially famous for *tambour* embroideries. The patterns were made with a metallic hook, having a wooden handle, on red broadcloth, black velvet or bright sateen. The combinations of different shades of red, yellow, dark blue, green and brown predominated in the ornament. The pattern consisted of bunches of flowers, elegant grasses, flexible stems and light, playful curls. In olden times the Nucha embroideries were highly appreciated. They were obligatory articles in the trousseau of each Azerbaijanian woman (Figure 8-8).

The Georgian *tambour* floral embroideries from Guria and Adjaria most often included the oriental ornament which was called *bob*. The embroideries of these regions are similar to Armenian and Turkish patterns in their style and were made using the same technique. As everywhere in the Caucasus, the Georgian *tambour* embroideries were made with colored silks which were supplemented by gold threads, *bit*, spangles and glass beads. Plain silk cloths served as the background. See Figure 4-7 for technique.

Embroidery with Glass Beads. In Georgia and Azerbaijan, women's dresses were decorated with multicolored patterns of glass beads. Such patterns were characterized by delicate colors, faintly resembling partitioned enamels. In Georgia, glass beads were most often used for decorating the forehead part of the national headdress.

In Azerbaijan, gowns were embroidered with glittering patterns along the cut, hem and on the sleeves. The multicolored ornament was often supplemented by gold threads and tinsel (Figure 8-2).

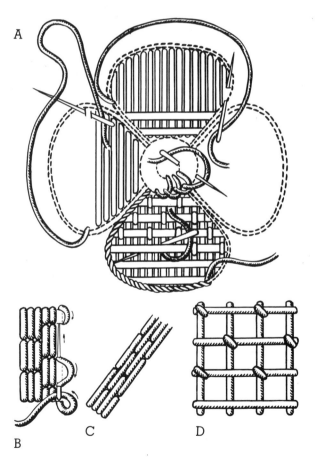

8–6. (A and D) the three-layer and loop stitch, (B and C) the two-sided satin stitch.

111

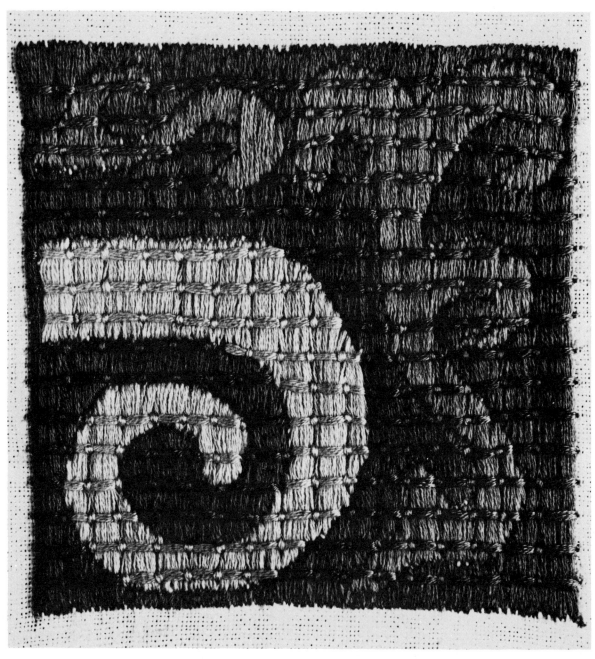

8–7. The three-layer stitch. (Photograph by V. M. Obukhova.)

8–8. A handbag embroidered with white and red silk on the dark blue atlas. (The Library of the Scientific Research Industrial Arts Institute.)

Gold Embroidery. As with *tambour*, embroideries with glittering metallic threads were very popular among the peoples of the Caucasus, but they were especially developed by the Georgian, Armenian, Azerbaijan and Adigeian embroiderers. The gold embroideries of Baku, Shemach, Tura, Adjaria and Erzrum were especially famous for their beauty. According to Shemach traditions the whole background was filled with glittering threads. In other centers of embroidery the background was not filled, the glittering pattern being clearly seen on the bright silk (Figure 8-9).

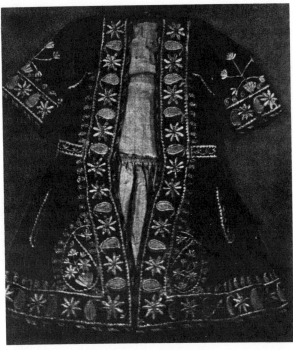

8–9. Street clothes made of velvet with gold embroidery. Shusha, the 19th century. (From Atakishieva: Azerbaijan Folk Clothes, Moscow, 1972, table 37. Photograph by V. M. Obukhova.)

Gold threads were used in the following techniques of embroidery: *proem* and fastening, *tambour* and feather stitch. The metallic spun threads were supplemented by *bit*, spangles, tinsel, pearls and precious stones.

The embroidery was done directly on the cloth, on the soft "flooring." Sometimes the motifs were done separately, and then were sewed on the cloth like an appliqué. After the motif was secured, a thin cord was put along the outlines of each form.

Specialists, called "cutters," who lived in Azerbaijan and Adigeian, cut patterns for embroidery out of paper. Usually, they prepared many patterns designed for different purposes beforehand. These stencils were secured to the cloth stretched in embroidery hoops. Then metallic threads were laid in parallel rows and were secured to the background with thin colored silk threads. The surface of the embroidered motif was either plain or had a small pattern consisting of geometric motifs created by the intercrossings of oblique and broken lines. Such patterns had the form of fir trees, lozenges, diagonals, and so on. Some of the patterns of fastening and the ways of laying metallic threads on the cloth which the Caucasian embroiderers used are shown in Figure 4-37.

Chapter 9

Embroidery of Siberia

Siberia occupies the vast territory from the Urals to the shores of the Pacific Ocean and from the Arctic Ocean to the south borders of Russia. The rigorous climate of the taiga, tundra, forest-tundra and the seacoast of cold seas have left their mark on the economic activities and the mode of life of the numerous peoples inhabiting this land. The main occupation of the indigenous population has always been reindeer-breeding, fur-bearing animal hunting, sea-animal hunting and, later, agriculture. The long winter accompanied by severe frosts determined the character of the house interiors as well as of the type of clothing worn by the people living on this rich but severe land. Everything was made out of fur and leather: fur coats, caps, shoes, carpets and other household articles. In the summer the people of the far east wore (and wear at present) dressing gowns of silk, cotton and woolen cloth. The people of the far north mainly used fur and broadcloth. These kinds of materials were also used in decorating household articles, the basis of the decoration being the ornament.

The women, primarily, made the clothes and household articles out of soft materials. After doing all the housework the woman would work on making either the necessary household articles or those designed for a future wedding (if the family had a daughter). The winter fur clothes of the people of the far north is of a special beauty. It is characterized by a great decorative expressiveness and colorfulness. The fur coats of the

Nenetzs, the Evenks, the Chukchis and the Yukagirs are characterized by the harmony of all the elements and the organic combinations of the materials of different texture, the basis of which was the glistening fur of the deer. The coats of some groups also had a collar made out of polar bear or red fox pelts. The coat had two edgings of heavy dog fur. Bright bands made of colored broadcloth were used as decorative insets in which red, dark blue, yellow and green predominated. They shaded the sleeves, hem and shoulders of this garment.

The Asian Nenetz women wore fur coats made from the beautiful fur of the spotted deer; this imparted a distinctive decorative effect to these fur coats. The fur coats, headdresses and shoes of the Yakut women were decorated with red broadcloth. The Evenks and the Dolgans most often combined fur with bright multicolored bands of glass beads in which white, black, red and preferred blue tones prevailed.

The most popular way of ornamenting winter fur coats and headdresses among the Chukchi was the fur mosaic. The pattern was made out of skillfully selected pieces of colored fur having a short nap. The richness of colors, the artistic use of different shades of fur and its texture, in combination with the use of bright broadcloth, glass beads and warm-toned chamois leather all created a joyous impression and turned the garment into a real work of high folk art (Figures 9-1, 9-2).

But, as usual, the costume of the bride was of

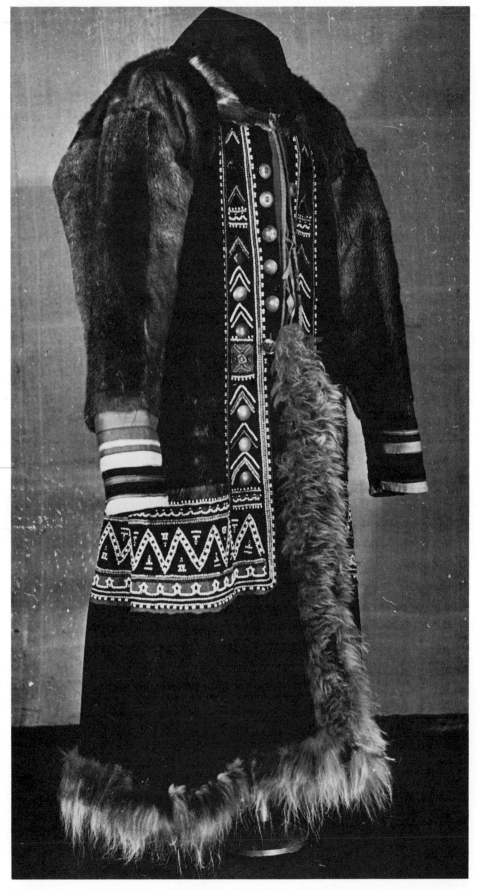

9–1A. A 20th century Dolgan fur coat embroidered with glass beads. (From Rainbow on the Snow, *Moscow, 1972, table 29.)*

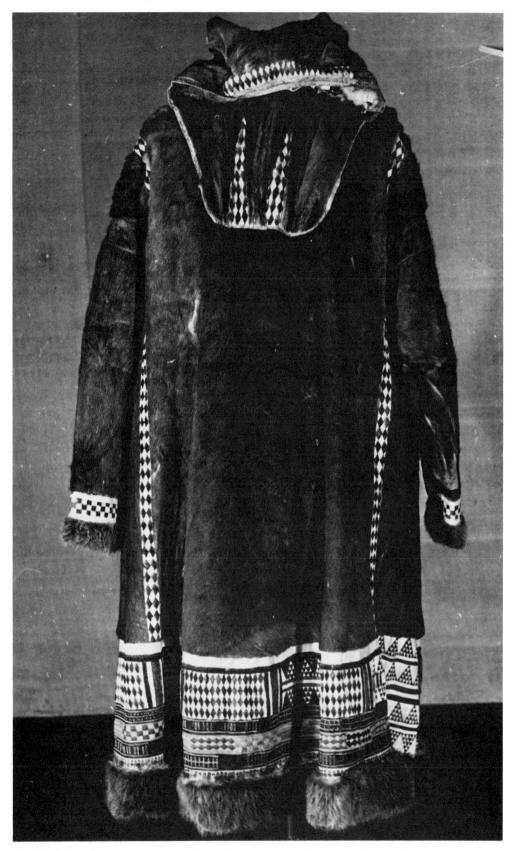

9–1B. *A fur coat made of deer fur with fur mosaic; the embroidery is done with colored silk. The Korjak national district. (Museum of Folk Art. Collection of photographs of the Scientific Research Industrial Arts Institute.)*

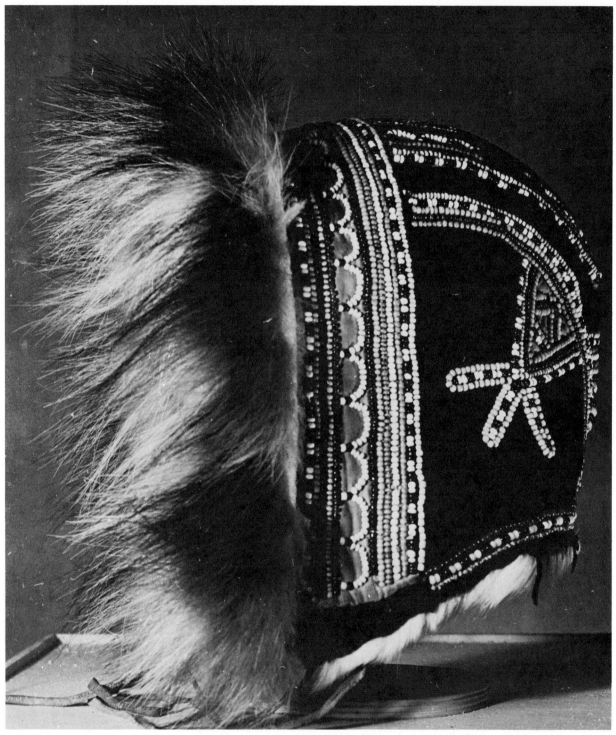

9–2. A man's Dolgan cap. Krasnojarsk Territory, the 20th century. (Museum of Folk Art. Collection of photographs of the Scientific Research Industrial Arts Institute.)

9–3. A carpet made of cotton colored cloths with appliqué and overstitches. The Nanaisk region of Chabarowsk Territory. (Museum of Folk Art. Collection of photographs of the Scientific Research Industrial Arts Institute.)

special beauty. This included a fur coat decorated with insets, fringe, glass beads and copper pendants. Such a colorful fur coat was belted by a multicolored silk belt. This costume was supplemented by a cap made of the best sable fur, on which a silver plate, the symbol of the Sun, and a fluffy bird feather plume was attached.

The ancient costume of the Yakut bride was supplemented by silver jewelry. Most often it was a massive flat ring which decorated the upper part of the front of the fur coat. The basic ring had a number of long small chains with pendants and bells.

Cotton and silk summer clothes were decorated with brightly colored appliqué, supplemented by overstitch embroidery. Household articles were made of the same materials and were decorated in the same manner. These included wall and floor carpets, covers, curtains and different kinds of bags (Figure 9-3).

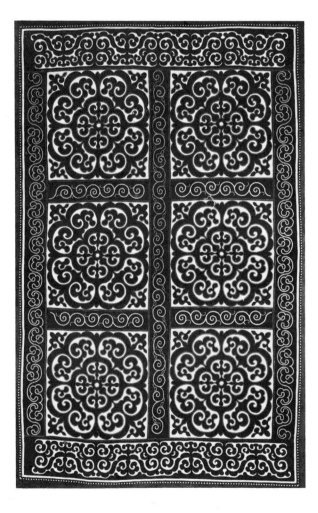

The ornament of the peoples of Siberia, used for decorating clothes and the household articles made from soft materials, is characterized by great diversity and largely depends on the technique of its execution. As for its proportions and its location, the ornament is always subject to the form and the size of the article. The peoples of the far north preferred geometrical ornaments.

Geometric motifs on soft materials are characterized by sharp breaks in lines. The pictures of meanders, zigzags, triangles, squares, plain bands, oblique checks and cross-shaped figures predominate on the fur clothes and bags.

The contour motifs for appliqué and the embroideries done with overstitches and glass beads are made not only with straight but also with rounded lines. The main motifs are as follows: ovals, circles, heart-shaped figures, rosettes and curls of different forms, small horns, double spirals, S-shaped figures and other simple forms (Figure 9-3).

In the process of their creative work, the folk embroiderers divide the basic forms or, on the other hand, they generalize them. They leave out unnecessary details and supplement traditional motifs with new elements. As a result of such changes in the forms, a new variant of the traditional pattern is born. The pattern is the ornamental row of figures which are repeated one after another. Sometimes the pattern is done in the form of a complex-figured rosette built on two or four intercrossing axes.

Patterns with floral motifs were very popular in the decoration of the clothes and household articles made out of soft materials. This kind of ornament was very often used for decorating women's clothes in the far east. Flowers, leaves, floral sprouts, bushes and trees formed simple and complex patterns. Pictures of birds and animals were also often used. The main picture was the image of the deer that symbolized the richness and happiness in the family.

Pictures of fantastic animals, especially the dragon, were very popular among the peoples of the Primorye and the Amur Territories. The long bodies of these animals, covered with fish scales, always coil; the head has horns and whiskers and sometimes it has the form of a curl. Fish, eagles, swans and cocks are rather popular motifs of the ornament of the Primorye and the Amur Territories. The bird often has a fish in its mouth.

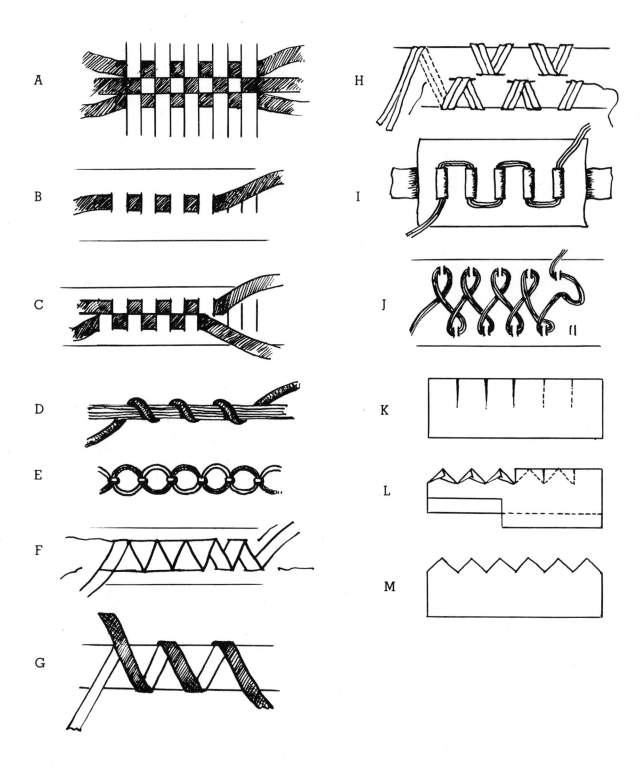

9–6. Different ways of ornamenting articles made out of leather and cloths: (A to C) narrow belts, (D to J) fastening of bundles of deer hair with different stitches, (K to M) appliqué on cloth.

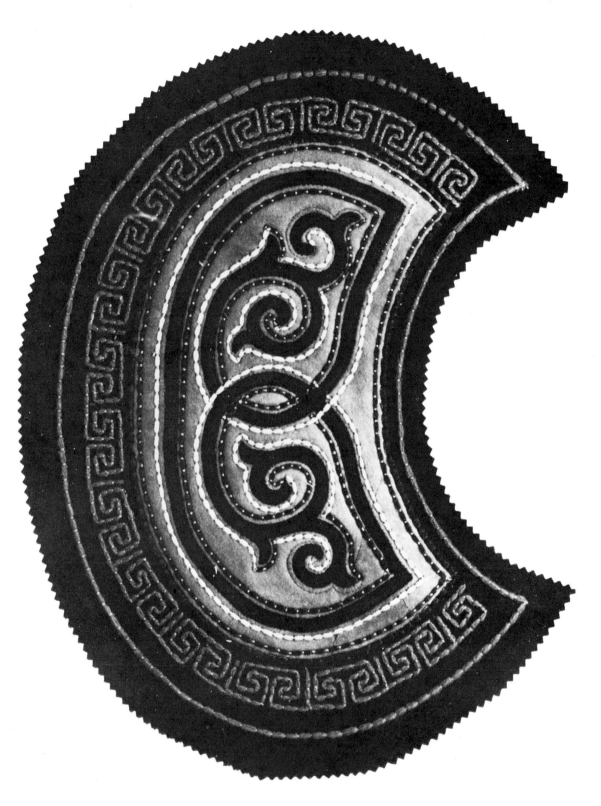

9–7. Appliqué and decorative stitches on leather made according to the motifs of Tuva folk art. (Photograph by V. M. Obukhova.)

Appliqué and Embroidery on Cloth

Wedding and holiday dressing gowns, wall carpets and other household articles out of factory-made cloth were decorated with multi-colored appliqué. This method of decorating various household articles is still very popular. Various patterns are used for decoration: geometric patterns having clear-cut linear and rounded lines, spiral-band motifs, stylized depiction of birds, animals and fishes (Figure 9-4).

According to ancient tradition the needle-women of the peoples of Siberia prepared the decorations beforehand to be used when needed. With this aim in mind, the necessary quantity of the appliqués was made, with the edges being done up and with the pattern being embroidered on each motif. The ornaments prepared in this way were kept for years. When needed, they were then sewn on clothes in definite places: near a low neck, on sleeves, along the hem and on the whole background of the cloth. There are two essential advantages in this way of decorating clothing. On the one hand, the needleworker does not always have the necessary cloth for making a garment. On the other hand, she is able to carefully select the fragments of the colored cloth and embroider them. That is why each article done in this way is always characterized by high artistic qualities.

The technique of appliqué of the needleworkers of the peoples of Siberia can be divided into several successive stages. First, they prepare a set of stencils from which the details of the ornament will be cut. For this purpose each planned form is outlined on paper or on thin birch bark. If the ornament is symmetric the paper is folded several times to get an exact copy of all the sides of the motif. After the picture is outlined, each form is cut with a sharp knife. The cloth is first covered with a mealy paste, dried and carefully ironed in order to prevent the edges of the forms cut out from breaking. The appliqué motifs prepared in this way are secured to the basic cloth with different stitches and in different ways. Besides the practical purpose, these stitches have decorative functions: they diversify the colors and the texture of the embroidery.

The articles made by the folk embroiderers are characterized by unusual beauty. The originality of their ornaments is emphasized by the color selections of the decorative stitches in which bright red, green, blue, yellow and orange tones in the contours of the motifs alternate with each other over short intervals. Some motifs are se-cured to the background with the help of the *tambour* or "loop" stitches. On other articles the needleworkers use a high satin-stitched roll under whose upper threads they put a narrow band made out of fish skin so that the upper threads are raised. To fix appliqué motifs to the basic background the needleworkers also used the colored *sutazh* or a narrow tight plait cut out of cloth. The Nanaj needleworkers edged appliqué motifs with a unique open work stitch resembling a zigzag. The needleworkers living in the Amur Territory used an edging turned inside out for securing appliqué motifs.

Glass Beads

The Evens, the Evenks, the Dolgans and the Ob Ugrs often use bright glass beads for decorating their winter garments, dressing gowns, collars, belts, shoes and household articles (Figure 9-2). The peoples of the north use the decorative qualities of the glass beads in different ways. The Evens generously embroider their beautiful golden-toned fur coats with stripes of colored glass beads. Here the predominating light-blue tones are organically combined with white, yellow and black insets which create strokes, rectangles, lozenges and simple rounded rosettes.

The glass bead pattern of the Dolgans alternates with fur mosaic or with bright insets made out of red broadcloth. The colored glass bead pattern was most often located on the red background which emphasized the hem, the front part, the pockets and the sleeves of fur coats or the upper part of caps. Glass beads of white, black and red colors were primarily used. The blue, white, golden, green and lilac toothed motifs of the ornament are characteristic of the Evens. The pattern on these ornaments is located in the form of bands or fills the upper oval part of the cap. The play of lights and needle-shaped forms of the pattern are associated with the Northern Lights, the fantastic undescribable phenomena of nature occurring against the dark background of the winter sky.

The technique of embroidering with glass beads is rather complicated: separate glass beads or a chain of glass beads threaded beforehand are sewn onto the fur, broadcloth or cloth. The folk embroiderers not only sew the colored glass beads on the background but also make open work nets out of them. Such open work colored nets are used for decorating the forehead, bodice and neck.

The description of the decoration of clothes and household articles of the peoples of Siberia finishes this review of the national embroidery of the numerous peoples inhabiting the vast territory of the Soviet Union.

The unusual inventiveness of the folk needleworkers is worthy of admiration. Their art was passed from generation to generation. Each age introduced something new, refining traditional motifs and forms, enriching the technique of embroidery, enlarging the decorative possibilities of the stitches, changing the coloring and the composition order of the pattern.

9–8. Appliqué and decorative stitches on leather according to the motifs of Tuva folk embroidery. (Photograph by V. M. Obukhova.)

Index